ISBN 978-0-265-95506-2
PIBN 10915138

SALE NUMBER 4297

FREE PUBLIC EXHIBITION

From Saturday, January 23rd, to Time of Sale
Weekdays 9 to 6 ⋅ Sunday 2 to 5

PUBLIC SALE

Friday and Saturday
January 29th and 30th
at 2 p. m.

EXHIBITION & SALE AT THE

AMERICAN ART ASSOCIATION
ANDERSON GALLERIES · INC

30 EAST 57TH STREET · NEW YORK

Sales Conducted by
HIRAM H. PARKE ⋅ OTTO BERNET ⋅ H. E. RUSSELL, JR

1937

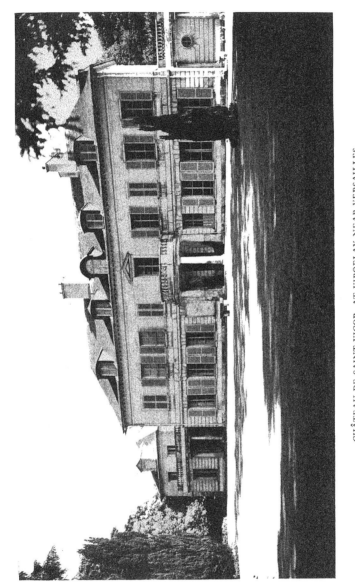

CHÂTEAU DE SAINT VIGOR, AT VIROFLAY NEAR VERSAILLES

French XVIII Century Furniture

INCLUDING IMPORTANT PIECES IN NEEDLEPOINT

French Engravings ⚹ Drawings ⚹ Paintings

INCLUDING LAWRENCE'S NOTABLE PAINTING OF

THE YOUNG DUC DE BORDEAUX

Choice Oriental Rugs ⚹ A Mortlake Tapestry
French Decorated Tole and Lacquer Objects

The Private Collection of

MRS TALBOT J. TAYLOR

Removed from Her Château
"Saint Vigor"
In the Vicinity of Versailles

SOLD BY HER ORDER

Public Sale January 29 and 30 at 2 p. m.

AMERICAN ART ASSOCIATION
ANDERSON GALLERIES · INC
1937

PRICED CATALOGUES

A priced copy of this catalogue may be
obtained for one dollar for each
session of the sale

CONDITIONS OF SALE

The property listed in this catalogue will be offered and sold subject to the following terms and conditions:

1. The word "Company", wherever used in these Conditions of Sale, means the American Art Association-Anderson Galleries, Inc.

2. The Company has exercised reasonable care to catalogue and describe correctly the property to be sold, but it does not warrant the correctness of description, genuineness, authenticity or condition of said property.

3. Unless otherwise announced by the auctioneer at the time of sale, all bids are to be for a single article even though more than one article is included under a numbered item in the catalogue. If, however, the articles under any one numbered item are designated as a "Lot" then bids are to be for the lot irrespective of the number of articles described in such item.

4. The highest bidder accepted by the auctioneer shall be the buyer. In the event of any dispute between bidders, the auctioneer may, in his discretion, determine who is the successful bidder, and his decision shall be final; or the auctioneer may reoffer and resell the article in dispute.

5. Any bid which is not commensurate with the value of the article offered, or which is merely a nominal or fractional advance over the previous bid, may be rejected by the auctioneer, in his discretion, if in his judgment such bid would be likely to affect the sale injuriously.

6. The name and address of the buyer of each article, or lot, shall be given to the Company immediately following the sale thereof, and payment of the whole purchase price, or such part thereof as the Company may require, shall be immediately made by the purchaser thereof. If the foregoing condition, or any other applicable condition herein, is not complied with, the sale may, at the option of the Company, be cancelled, and the article, or lot, reoffered for sale.

7. Unless the sale is advertised and announced as an unrestricted sale, or a sale without reserve, consignors reserve the right to bid.

8. Except as herein otherwise provided, title will pass to the highest bidder upon the fall of the auctioneer's hammer, and thereafter the property is at the purchaser's sole risk and responsibility.

9. Articles sold and not paid for in full and not taken by noon of the day following the sale may be turned over by the Company to a carrier to be delivered to a storehouse for the account and risk of the purchaser, and at his cost. If the purchase price has not been so paid in full, the Company may either cancel the sale, and any partial payment already made shall thereupon be forfeited as liquidated damages, or it may resell the same, without notice to the buyer and for his account and risk, and hold him responsible for any deficiency.

[A]

10. If for any cause whatsoever any article sold cannot be delivered, or cannot be delivered in as good condition as the same may have been at the time of sale, the sale will be cancelled, and any amount that may have been paid on account of the sale will be returned to the purchaser.

11. In addition to the purchase price, the buyer will be required to pay the New York City sales tax, unless the buyer is exempt from the payment thereof.

12. The Company, subject to these Conditions of Sale and to such terms and conditions as it may prescribe, but without charge for its services, will undertake to make bids for responsible parties approved by it. Requests for such bidding must be given with such clearness as to leave no room for misunderstanding as to the amount to be bid and must state the catalogue number of the item and the name or title of the article to be bid on. If bids are to be made on several articles listed as one item in the catalogue, the request should state the amount to be bid on each article, unless the item contains the notation "Lot", in which case the request should state the amount to be bid "For the Lot". The Company reserves the right to decline to undertake to make such bids.

13. The Company will facilitate the employment of carriers and packers by purchasers but will not be responsible for the acts of such carriers or packers in any respect whatsoever.

14. These Conditions of Sale cannot be altered except in writing by the Company or by public announcement by the auctioneer at the time of sale.

SALES CONDUCTED BY HIRAM H. PARKE, OTTO BERNET, AND H. E. RUSSELL JR.

AMERICAN ART ASSOCIATION
ANDERSON GALLERIES · INC
30 EAST 57TH STREET · NEW YORK

Telephone PLAZA 3-1269 *Cable* ARTGAL *or* ANDAUCTION

HIRAM H. PARKE · *President*

OTTO BERNET · *Vice-President* ARTHUR SWANN · *2nd Vice-President*

[A]

ORDER OF SALE

FOREWORD

THE latter half of the seventeenth century saw France established as the cultural centre of Europe, a position previously held by Italy. History credits the French monarch of that period, Louis XIV, as the chief instigator and sponsor of France's rise to pre-eminence in the field of the arts. His magnificent palace of Versailles set a new standard in Europe for royal residences. The building of Versailles coincided with the beginnings of a new chapter in the history of the decorative arts. Here we may mark a departure from the pseudo-feudal atmosphere that had characterized the interiors of the great royal and princely houses up to this time. In the new order we note a decided emphasis on color and symmetry, which in itself was one of the many manifestations of the rational hedonism of eighteenth century France. The rise in the commercial prosperity of the nation resulted in a large increase in the number of well-to-do *bourgeoisie,* from whom arose a demand for furniture in the fashion set by the Court. Foreign craftsmen were attracted to a field that promised such rich rewards to the extent that laws were instituted governing the conditions of the *ébéniste* guild. These stipulated that each applicant for admission to membership should undergo a long period of apprenticeship and attain a certain standard of workmanship. Salverte tells us that the craft had the protection of the Church and University, besides the patronage of the Court, and that the foregoing protected free work (duty free) in certain sections of the city. One of these "privileged places" was the Faubourg Saint-Antoine, which since the sixteenth century had sheltered a colony of artisans of all trades. We learn further from Salverte that in 1723 there were eight hundred and ninety-five *maîtres-menuisiers* (master joiners) in Paris, and in 1790 there were the same number, among which were about two hundred *ébénistes* and one hundred chairmakers. Thus we have the spectacle of a highly skilled craft dictating European fashions and enjoying the benefits of a wise civic control.

Versailles continued during the subsequent reigns to be the principal residence of the Court, and in the environs there came into existence a number of châteaux built by members of the Court, who, although having their apartments in the Palace, desired their personal *Maisons des Champs* or *Maisons des Plaisances.* The Château de Saint Vigor at Viroflay, in the shadow of Versailles, was one of these; it was the residence of the Comte de Saint Vigor, foster brother of Louis XV. While certain details in its construction support the belief that it is not the work of Gabriel, it is un-

doubtedly by one of his best pupils. The Château de Saint Vigor when acquired by Mrs Talbot Taylor had survived the transformations which characterize so many French country houses of this period, a fact which prompted Mrs Taylor to restore to this beautiful house the furniture and *bibelots* that would make it live again. It is these furnishings, paintings, and decorative objects that are now offered for sale.

The furniture comprises a brilliant assortment of chairs and settees in suites and singly, mostly in fine needlepoint, commodes, bureaus, secretaries and tables, of the Louis XIV to Directoire periods, and includes a number of excellent cabinet pieces of the latter period evidencing the pure classicism in vogue at that time. Specifically, we may note a beautiful Louis XV suite of six *fauteuils* and a *canapé* [Numbers 226 to 229, inclusive] in needlepoint and lampas, the frames by the *maîtres-menuisiers* Pierre Laroque and Noël Boudin. Another beautiful suite comprises the four Louis XV *fauteuils* [Numbers 217 and 218] covered in the extremely rare *petit point de St Cyr* and worked with subjects from Cervantes' *Don Quixote*, one pair of which is attributed to Pierre-Martin-Dominique Boissier, the other pair by Pierre Malbet and Noël-Toussaint Porrot. This fine furniture occurs in both sessions of the sale.

The second session contains a colorful group of decorative Louis XV and Louis XVI portraits, mostly French, with a few Venetian subjects. By Jean Fréderic Schall there is a dainty miniature full-length figure of a lady [Number 172]; by Jean Raoux, the graceful *Leçon de Musique* [Number 181]. A brilliant and fluently painted portrait [Number 182] depicts the *Duc de Bordeaux,* a charming blue-eyed child, the son of the Duchesse de Berri, whose portrait Lawrence painted at the time of his visit to Paris for the sittings of King Charles X. This was the grandchild, then a small boy playing in Lawrence's studio, whom Charles, upon abdication, proclaimed his successor; and who died as the Comte de Chambord, the last hope of the Legitimists. The catalogue also includes over twenty lots of French engravings and original drawings.

In addition to the foregoing, the collection contains a small group of Oriental rugs of exceptional quality, including two Royal Persian animal rugs [Numbers 271 and 272], of sixteenth century design and showing superb knotting. The Mortlake tapestry [Number 265], illustrating the meeting of Antony and Cleopatra, is a fine example of English tapestry weaving. Finally, among the complementary small objects is an extensive assortment of tole and lacquer articles of the eighteenth and early nineteenth centuries, of a quality and variety rarely encountered.

CHARLES PACKER

FIRST SESSION

Friday, January 29, 1937, at 2 p.m.

DECORATIVE AND ANTIQUE SILVER

1. FOUR CHASED GILDED SILVER PRESENTATION SPOONS
 Probably Dutch, together with a small spoon, fork, and cheese scoop.
 [Lot.]

2. SEVEN FLORENTINE SILVER SKEWERS
 The handles formed as heads of animals, birds and fishes; stamped
 with the mark of a Florentine silversmith. *Length, about 9 inches*

3. PAIR DUTCH CHASED SILVER PRESENTATION SPOONS
 The handles formed as rococo figures; probably eighteenth century.
 Length, 7¼ inches

4. SILVER-MOUNTED CUT GLASS CLARET JUG
 Elaborately cut with diamond ornament and fluting; chased silver neck
 and handle. *Height, 11 inches*

5. SILVER-MOUNTED CUT GLASS CLARET JUG *English, XIX Century*
 Nicely flat-cut in the Renaissance taste, the silver mounts richly chased;
 Victorian marks. *Height, 12 inches*

6. EMPIRE CHASED SILVER CREAM PITCHER
 Chased with swags of flowers. *Height, 8 inches*

7. PAIR AJOURÉ STERLING SILVER BONBON DISHES
 Pierced and chased with rococo ornamentation. *Diameter, 7 inches*

8. GEORGIAN SHEFFIELD PLATE INKSTAND AND PAIR CANDLESTICKS
 Inkstand oblong with hinged cover and four feet and fitted with two
 glass ink pots. Pair of small candlesticks chased with rams' masks.
 [Lot.]

9. TWO DUTCH REPOUSSÉ SILVER BONBON DISHES
 In the form of seventeenth century bleeding cups, chased with figures
 and foliage. *Length, 5 inches*

10. EMPIRE SILVER AND CUT GLASS MOUTARDIER *French, circa* 1810
Circular, with hinged cover, chased handle and feet, and glass liner.
Height, 4¼ inches

11. TWO ANTIQUE FRENCH SILVER WINE TASTERS
Embossed in rosette design with reeded loop handles; one inscribed.
Diameter, 3 inches

12. TWO ANTIQUE FRENCH SILVER WINE TASTERS
Somewhat similar to the preceding. *Diameter, about 2¾ inches*

13. TWO ANTIQUE FRENCH SILVER WINE TASTERS
Somewhat similar to the preceding. *Diameter, about 2¾ inches*

14. TWO ANTIQUE FRENCH SILVER WINE TASTERS
Somewhat similar to the preceding. *Diameter, about 2¾ inches*

15. TWO ANTIQUE FRENCH SILVER WINE TASTERS
Somewhat similar to the preceding. *Diameter, about 2½ to 3 inches*

16. REPOUSSÉ SILVER NAUTILUS CUP *Augsburg(?), XVIII Century*
Richly chased with *putti* masks and griffins. *Height, 8 inches*

17. SILVER AND CUIVRE DORÉ CHALICE *Augsburg(?), XVII Century*
The tulip-shaped bowl of silver encircled by a molded rim and surmounting a baluster-shaped stem and flaring base of gilded copper chased with strapwork and flowers. *Height, 10½ inches*

[See illustration]

18. LOUIS XVI AJOURÉ SILVER SUGAR BASKET *French, XVIII Century*
Helmet-shaped, with swivel handle pierced with fluting and interlaced onament; blue glass liner. *Height, 5½ inches*

[See illustration]

19. REPOUSSÉ GILDED SILVER POKAL *Nuremberg, circa* 1700
Bowl, cover, and spreading foot elaborately chased with strapwork and cabochons and with animalistic finial. *Height, 9½ inches*

[See illustration]

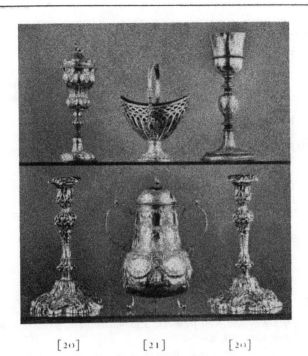

[20] [21] [20]

TOP ROW: NUMBERS 19-18-17

20. SET OF SIX SILVER REPOUSSÉ SILVER CANDLESTICKS

Howard & Co., New York

Elaborately chased and molded in the rococo style. *Height, 11 inches*

[See illustration of two]

21. REPOUSSÉ SILVER HOT-WATER URN *Dutch, XVIII Century*

Bulbous, with domed cover and scrolled handles and three short legs;
chased with swags of fruits and flowers and acanthus.

Height, 10 inches

[See illustration]

22. DIRECTOIRE SILVER-PLATED GIRANDOLE

With two shaped arms supporting sconces for candles and an adjust-
able reflector lined with silk brocade. *Height, 21 inches*

23. PAIR AJOURÉ STERLING SILVER FRUIT DISHES

Black, Starr & Frost, New York

Oval, elaborately pierced and chased with rococo ornamentation.

Length, 14 inches

24. REPOUSSÉ STERLING SILVER FRUIT DISH

Theodore B. Starr, New York

Elaborately chased with flowers and foliage; monogrammed.

Length, 13½ inches

25. LOUIS XVI FLUTED SILVER OVAL DISH *French, circa 1780*

Boat-shaped with fluted sides and molded rim; monogrammed underneath.

Length, 17 inches

FRENCH DECORATED TOLE TRAYS
LAMPS AND JARDINIERES

26. PAIR CHARLES X DECORATED TOLE URNS

French, Early XIX Century

Square beaker with paw feet and square base, painted with romantic landscapes and figures.

Height, 10 inches

[See illustration on page 28]

27. DIRECTOIRE DECORATED TOLE JARDINIERE

French, Late XVIII Century

Oval with scalloped rim simulating red-figured Etruscan ware. Together with three red and gold ash trays of later date. [Lot.]

Length of jardiniere, 13 inches

28. DIRECTOIRE DECORATED TOLE URN

Painted with a figural medallion and nosegays of flowers in a "marbled" green ground.

Height, 13 inches

29. LOUIS XVI DECORATED TOLE OVAL TRAY *French, XVIII Century*

Painted *en grisaille* with a group of nymphs and amors after Watteau, in a red and gold ground.

Length, 17 inches

30. PAIR DIRECTOIRE DECORATED TOLE URNS

Coniform urn with pointed cover and flaring foot simulating Chinese black and gold lacquer.

Height, 13 inches

[See illustration on page 51]

31. LOUIS XVI DECORATED TOLE TRAY *French, XVIII Century*
Painted with Marie Antoinette flowers and ribbon ornament; silver-plated border. *Length, 17½ inches*

32. DIRECTOIRE BLACK AND GOLD TOLE HOT-WATER URN
French, circa 1800
Cylindrical, with *ajouré* square base and pointed domed top.
Height, 18 inches

33. PAIR LOUIS XVI DECORATED TOLE TEA CADDIES
French, XVIII Century
Lacquered with medallions of *chinoiserie* figures in green and brown grounds. *Width, 5½ inches*

34. PAIR DIRECTOIRE DECORATED TOLE URNS
Flaring square beaker on "marbled" base, painted with Pompeiian motives in a soft lavender, yellow, and gold ground; with loose liner.
Height, 10½ inches
[See illustration on page 14]

35. DIRECTOIRE DECORATED TOLE URN
Boat-shaped, with swan-form handles and a painted figural medallion in a green ground. *Length, 13 inches*

36. DIRECTOIRE DECORATED TOLE TRAY *French, Late XVIII Century*
Oblong, with pierced border painted with flowers in a soft green ground. *Length, 18 inches*

37. TWO LOUIS XV DECORATED TOLE JARDINIERES
French, XVIII Century
Cylindrical, lacquered with *chinoiserie* figures and landscapes in oval reserves; one with a black ground, one with a ground simulating *nashiji* lacquer; one handle missing. *Height, 7 inches*

38. EMPIRE DECORATED TOLE GARNITURE
Comprising a pair of tapered baluster urns on "marbled" square bases, painted with marine vignettes in a red and gold ground; and a covered bowl somewhat similar. [Lot.] *Heights, 9 and 12½ inches*
[See illustration on page 29]

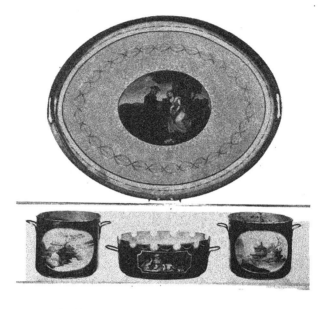

[39] [40] [39]

TOP ROW: NUMBER 41

39. PAIR LOUIS XV DECORATED TOLE JARDINIERES

French, XVIII Century

Cylindrical, with loop handles, lacquered with a *chinoiserie* landscape in ivory and gold in a coral red ground. *Height, 6½ inches*

[See illustration]

/o o—

40. PAIR LOUIS XVI DECORATED TOLE JARDINIERES

French, XVIII Century

Oval, with serrated rim and two handles, painted *en grisaille* with medallions of nymphs and amors in a crimson ground with vines and bead festoons. *Length, 13 inches*

[See illustration of one]

/2 o

6

41. DIRECTOIRE DECORATED TOLE OVAL TRAY

French, Late XVIII Century

Painted with a pair of lovers in a landscape in a light green ground, with a band of interlaced pink ribbon. Arranged as a coffee table, on a lacquered wood stand.　　　　*Length, 26 inches*

[See illustration of tray]

42. LOUIS XVI DECORATED TOLE OVAL TRAY *French, XVIII Century*

Painted with a landscape vignette in a medallion in a rose pink ground, the border pierced.　　　　*Length, 20 inches*

43. PAIR DIRECTOIRE DECORATED TOLE JARDINIERES

French, XVIII Century

Oval, with scalloped rim, painted with marines after Vernet in a white-stippled gray ground with gilded borders.　　　　*Length, 13 inches*

44. DIRECTOIRE BLACK AND GOLD TOLE HOT-WATER URN

Three-legged urn with shaped stand and pointed cover.

Height, 16½ inches

45. DIRECTOIRE DECORATED TOLE OVAL TRAY

French, Late XVIII Century

Painted with a landscape vignette in a crimson ground gilded with bands of oak leaves and acorns.　　　　*Length, 21½ inches*

46. PAIR CHARLES X DECORATED TOLE URNS

French, Early XIX Century

Small square beaker painted with figural and landscape vignettes, on paw feet and "marbled" square base.　　　　*Height, 7 inches*

47. DIRECTOIRE BLACK AND GOLD TOLE KETTLE ON STAND

Gilded with rococo ornamentation, on *ajouré* stand with scrolled legs.

Height, 14 inches

48. DIRECTOIRE BLACK AND GOLD TOLE HOT-WATER URN

Three-legged vasiform body with pointed cover, painted and gilded with flowers and figures of Ceres.　　　　*Height, 15 inches*

49. Two Directoire Decorated Tole Jardinieres
Oval, on flaring foot, one with pierced rim, one with swivel handle;
simulating Chinese black and gold lacquer. *Height, 15 inches*

/ɔ ɔ -

50. Empire Green and Gold Tole Lamp
Of columnar form, fitted for three lights, with a tole shade.
 Height, 28½ inches

ƒo-

51. Two Directoire Tole Lamps *French, circa 1800*
Of columnar form, one black and gold, one yellow; fitted for electricity.
 Heights, 18 and 20 inches

ƒo

52. Directoire Decorated Tole Oval Tray
 French, Late XVIII Century
Painted with a peasant girl in an oval medallion in a crimson ground
gilded with a band of bay leaves. *Length, 24½ inches*

[See illustration on page 16]

4ƒ-

53. Directoire Decorated Tole Oval Tray
 French, Late XVIII Century
Painted with a figure in a chariot, framed by a band of amatory and
musical emblems in the colors of Etruscan black-figured pottery.
 Length, 30 inches

4/o

54. Pair Directoire Black and Gold Tole Lamps
Slender vasiform lamp with square base, in the Grecian taste; fitted for
electricity. *Height, 27 inches*

//o

55. Pair Directoire Green and Gold Tole Lamps
Slender ovoid body painted *en grisaille* with figures, on "marbled"
square base; fitted for electricity. *Height, 22 inches*

/ʔo

56. Five Pieces of Directoire Decorated Tole Ware
 French, Late XVIII Century
Small octagonal tray, a *cachepot,* and a chocolate pot, decorated in red
and gold; together with a pair of candlesticks. [Lot.]

6 o

FRENCH DECORATED LACQUER TRAYS AND BOXES

57. LACQUER BOX AND LEATHER JEWEL CASE
French, XVIII-XIX Century
30— Circular box with painted landscape on lid. Tooled and gilt leather
jewel case. [Lot.] *Widths, 6 and 8½ inches*

58. VERNIS MARTIN COFFRET French, XVIII Century
With slightly domed lid, decorated with panels of flowers and birds in
15 a gold ground. *Length, 14 inches*

59. DECORATED LACQUER BOÎTE DE TOILETTE French, XVIII Century
Fitted small box, with mirror, painted with Huet chinoiserie figures and
flowers. *Length, 7½ inches*
15

60. BLACK AND GOLD LACQUER COFFRET
Chinese, for the European Market, XVIII Century
27 10 With slightly domed lid and bronze handles. *Length, 13 inches*

61. BLACK AND GOLD LACQUER TEA CADDY CASKET
Chinese, for the European Market, circa 1820
15 Oblong, fitted with two engraved pewter tea caddies.
Length, 10 inches

62. BLACK AND GOLD LACQUER TRAY French, Early XIX Century
Oblong, gilded with chinoiserie. *Length, 17½ inches*
25

63. BLACK AND GOLD LACQUER TEA TRAY French, XVIII Century
Shaped and molded border, centre gilded with flowers and birds in a
black ground in the Chinese taste. *Length, 35 inches*
77 10 [See illustration on following page]

64. BLACK AND GOLD LACQUER TEA TRAY French, XVIII Century
Similar in shape to the preceding, gilded with a Chinese landscape in a
60— black ground. *Length, 34 inches*

9

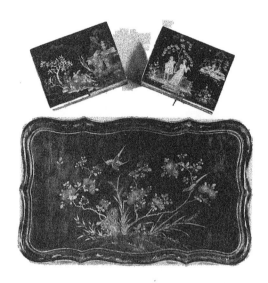

[NUMBER 63]

TOP ROW: NUMBERS 66 AND 65

65. BLACK AND GOLD LACQUER COFFRET *French, XVIII Century*
Gilded with *chinoiserie* figures in a black ground; slightly domed lid.
Length, 12 *inches*
[See illustration]

66. BLACK AND GOLD LACQUER COFFRET *French, XVIII Century*
Simulating Chinese lacquer, the lid slightly domed.
Length, 12½ *inches*
[See illustration]

67. TWO BLACK AND GOLD LACQUER BOXES *French, XVIII Century*
One fitted with four small boxes and both decorated with *chinoiserie*.
Lengths, 7½ *inches*

68. BLACK AND GOLD LACQUER COFFRET *French, XVIII Century*
Oblong, with slightly domed lid, simulating Chinese lacquer.
Length, 14 *inches*

10

69. BLACK AND GOLD LACQUER COFFRET *French, XVIII Century*
Decorated with *chinoiserie* and rocaille ornamentation.
Length, 11 inches

70. RED AND GOLD LACQUER WORK BOX
Chinese, for the European Market, circa 1820
Oblong, with hinged lid. *Length, 13 inches*

71. BLACK AND GOLD LACQUER WRITING BOX
Chinese, for the European Market, circa 1800
Hinged portable desk with fitted interior. *Length, 17 inches*

72. BLUE AND GOLD LACQUER COFFRET *French, Early XVIII Century*
Miniature chest with domed lid, simulating Chinese lacquer.
Length, 11 inches

73. LOUIS XV CHINOISERIE LACQUER TRAY MOUNTED IN BRONZE DORÉ
Decorated with a Chinese landscape; handsomely chased border and
handles of gilded bronze. *Length, 26 inches*

74. DECALCOMANIE DECORATED COFFRET *French, XVIII Century*
Decorated with rococo figures and flowers in colored transfer.
Length, 11½ inches

FRENCH XVIII CENTURY FURNITURE
AND DECORATIONS

75. FOUR DECORATIVE SMALL OBJECTS
Empire *bronze doré* snuffers tray, Dresden porcelain snuff box, and
pair Canton trencher salts. [Lot.] *Lengths, 3½ inches and 9 inches*

76. REPOUSSÉ SILVERED METAL SALT CELLAR *Spanish, XVIII Century*
In the form of a nautilus cup, with hinged lid and flaring foot.
Height, 5 inches

77. MARSEILLE DECORATED FAÏENCE INKSTAND *XVIII Century*
Octagonal, painted in cobalt and *rouge de fer* with leafage and ara-
besques and with two glass inkpots in silver sockets.
Length, 9 inches

78. TERRE D'AVIGNON COVERED BOWL *XVIII Century*
 Modeled and glazed in the form of a cauliflower. *Height, 7 inches*
 [See illustration on page 18]

100

79. CHINESE DECORATED PORCELAIN BOWL *Chia Ch'ing*
 Kidney-shaped bowl painted and enameled with fish and bands of
 flower, cloud and *ju-i* ornament; has stand. *Width, 8¼ inches*
 [See illustration on page 18]

30-

80. LOUIS XVI BRONZE DORÉ PENDULE
 Of columnar form, embellished with laurel swags and surmounted by
 an urn finial. *Height, 11 inches*
 [See illustration facing page 26]

170-

81. DECORATED PORCELAIN BOWL *Samson, Paris*
 In Oriental Lowestoft style, handsomely painted and gilded with
 flowers and an armorial escutcheon; with gilded metal base.
 Diameter, 9½ inches

60

82. TWO DECORATIVE OLD CERAMICS
 Chinese blue and white porcelain square bottle, partly gold lacquered,
 and an ivory faïence oval basketware dish. [Lot.]

12

83. PAIR LOUIS XVI BRONZE DORÉ CANDLESTICKS AND
 A DIRECTOIRE SHAVING MIRROR
 Candlestick with fluted baluster stem, urn top and beaded circular base.
 Circular shaving mirror on fluted stand: [Lot.]

84. MAHOGANY AND BRASS COFFEE MILL *French, XVIII Century*
 Embellished with turned pilasters, and with nice patina.
 Height, 12 inches

85. IVORY MAH JONG SET IN AMBOYNA WOOD CASE
 Case veneered with richly figured wood, with ivory handle.
 Length, 9½ inches

86. TURNED WALNUT YARN WINDER *Provençal, XVIII Century*
 A table spinning wheel apparently in working condition.
 Length, 14 inches

12

87. DECORATIVE FRENCH POTTERY CENTRE BOWL

50 Molded with Chinese figures and glazed green and terra cotta red.
 Diameter, 13½ inches

88. TWO JAPANESE PAINTINGS ON GLASS

30 One with a view near Mt Fujiyama, and the other with a garden with
 pavilions. *Height, 13 inches; length, 16 inches*

89. TWO JAPANESE PAINTINGS ON GLASS

35 Depicting lake scenes near Mt Fujiyama.
 Height, 10 inches; length 14 inches

90. LOUIS XV BRONZE-MOUNTED STEEL SHOVEL AND TONGS
 French, XVIII Century

75 Enriched with gilded bronze finials of fluted baluster form. [Lot.]
 Length, 27 inches

91. DIRECTOIRE BRONZE AND CRYSTAL CHANDELIER

50 Wired for three electric lights. *Height, 26 inches; width, 13 inches*

92. LOUIS XVI CARVED WALNUT AND NEEDLEPOINT FOOTSTOOL
 French, Late XVIII Century

60 Oblong top covered in *pavot* needlework, on turned short legs.

93. BLACK AND GOLD LACQUER WORK TABLE
 Chinese, for the European Market, Early XIX Century

40 Hinged oblong top uncovering fitted interior furnished with a silk sew-
 ing bag, on lyre-shaped end supports with carved paw feet; one leg
 repaired. *Height, 28 inches; width, 25 inches*

94. LOUIS XV CARVED AND DECORATED LAC CONSOLE
 Venetian, XVIII Century

200 Shaped top lacquered to simulate Siena marble, the gracefully voluted
 frieze and supports carved with delicate leaf vines and painted white
 and gold. *Height, 31 inches; width, 39 inches*

95. LOUIS XVI CARVED AND LAQUÉ FAUTEUIL *French, XVIII Century*

140 White frame carved with fluting, guilloche, and rosettes, the arched
 back, armpads, and seat cushion covered in ivory and pale blue figured
 silk.

13

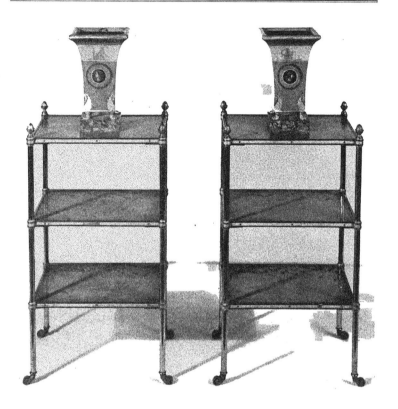

[NUMBER 96]

DIRECTOIRE TOLE URNS: NUMBER 34

96. PAIR DIRECTOIRE SATINWOOD AND BRONZE DORÉ ETAGÈRES

French, circa 1800

Three-tier stand for books or *bibelots*, with satinwood square shelves and gilded bronze slender supports.

Height, 27 *inches; width,* 14 *inches*

[See illustration]

14

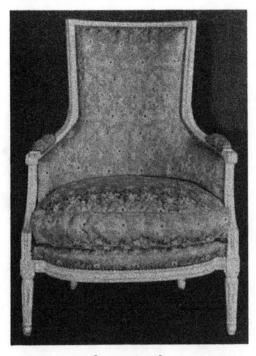

[NUMBER 97]

97. LOUIS XVI WHITE LAQUÉ AND
 SALMON PINK SILK BROCADE BERGÈRE *French, XVIII Century*
 Handsome chair in the style of Jacob, with rectangular back, slightly
 outcurved arms, bowed seat, and fluted and tapered short legs; frame
 molded, the dies carved with leaf medallions. Covered in silk brocade
 patterned with a small floral motive; loose seat cushion.
 [See illustration]

200—

98. PAIR LOUIS XV CARVED BEECHWOOD AND PETIT POINT FAUTEUILS
 French, XVIII Century
 Small cabriolet chair of mid-eighteenth century type, the shaped back,
 seat, and armpads covered in *petit point* designed with sprays, wreaths
 and bouquets of flowers and leaves in a white ground. The frame
 carved with small groups of flowers on the crest, knees, and skirt.

700—

15

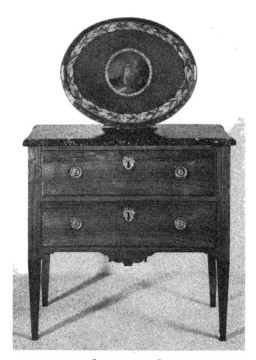

[NUMBER 99]

DIRECTOIRE TOLE TEA TRAY: NUMBER 52

99. LOUIS XVI SMALL TULIPWOOD COMMODE

Louis Moreau (M.E. 1764); French, XVIII Century

Two-drawer commode of pleasing simplicity, the front enriched with gilded bronze ring handles and key plates; the plain stiles extended into square tapered legs with bronze shoes. Stamped L. MOREAU, under the gray Ste Anne marble top.

Height, 33 inches; length, 35½ inches

Note: Louis Moreau (c. 1740-1791) passed master in 1764; established himself in the Rue de l'Echelle-Saint-Honoré and employed Charles Topino, who afterwards became one of the leading *ébénistes* of the Louis XVI epoch. Signed examples of Moreau's work include a commode in the Lafaulotte collection and a commode in the Chateau de Voisenon, near Melun.

[See illustration]

16

100. LOUIS XV BURL WALNUT PETITE COMMODE
French or Italian, XVIII Century
Small *bombé* commode, the front enclosed by two doors with a drawer above; tray top and tapering curved supports. Top and sides veneered with richly figured walnut. *Height, 35½ inches; width, 18½ inches*

101. LOUIS XVI CARVED LACQUÉ AND CANNÉ CHAIR
French, XVIII Century
Molded oval back and circular seat filled with cane; fluted round tapering supports with leaf-carved sides; lacquered white and furnished with a seat cushion.

102. DIRECTOIRE ACAJOU BUTLER'S TRAY ON STAND *French, circa 1800*
Rectangular, with hinged sides and brass handles, on original folding X-shaped supports. *Height, 28 inches; length, 41 inches*

103. LOUIS XVI CARVED AND LAQUÉ SIDE CHAIR IN PETIT POINT
French, XVIII Century
Oval back and shaped seat covered in needlepoint designed with bouquets and sprays of flowers and leaves in a light ground. Molded frame and fluted round tapering legs, painted white.

104. TULIPWOOD PARQUETERIE READING TABLE *Louis XVI Style*
Long narrow top with hinged tablet on strut. Inlaid in a parqueterie design; on slender trestle legs. *Height, 27 inches; length, 36 inches*

105. LOUIS XV CARVED WALNUT AND BLUE SILK FAUTEUIL
French, XVIII Century
With molded and voluted frame and supports, carved with small groups of flowers on the crest, knees, and skirt. Covered in flowered Nattier blue silk. Some restoration.

17

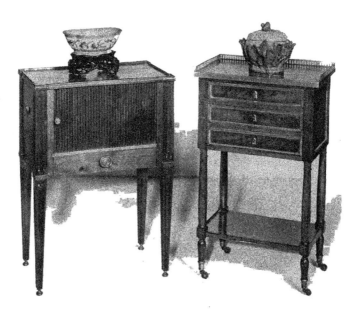

[NUMBER 107] [NUMBER 106]

TWO BOWLS: NUMBERS 78 AND 79

106. LOUIS XVI ACAJOU TABLE DE CHEVET MOUNTED IN BRONZE DORÉ

French, XVIII Century

140 — Small three-drawer table with round tapering supports connected by an undershelf. Gray Ste Anne marble top bordered with a bronze gallery; the drawers enriched with gilded *cuivre doré* moldings.

Height, 29½ inches; width, 18 inches

[See illustration]

107. LOUIS XVI CERISIER TABLE DE CHEVET

French, Late XVIII Century

100 Small cabinet table with tray top, the front enclosed by a tambour shutter, a drawer below; the sides pierced with heart-shaped openings for carrying purposes. On fluted square tapering legs; one leg repaired.

Height, 28½ inches; width, 20 inches

[See illustration]

18

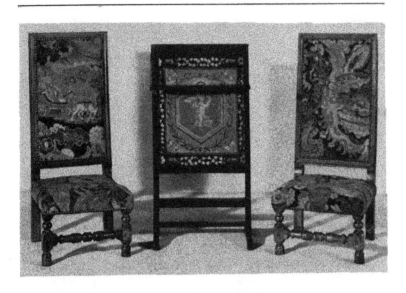

[108] [109] [108]

108. PAIR LOUIS XIII TURNED WALNUT AND
 NEEDLEPOINT CHAUFFEUSES *French, XVII Century*
 Low fireside chair with a high rectangular back. The back and seat
 covered in *petit* and *gros point* designed with mythological subjects and
 baroque foliage in colors. Walnut turned short legs and stretchers.

[See illustration]

109. DIRECTOIRE ACAJOU AND AUBUSSON TAPESTRY FIRE SCREEN
 French, Late XVIII Century
 Small *cheval* screen framing a rising panel of silk-woven tapestry fea-
 turing an amor in a hexagonal medallion framed with laurel wreath,
 in a yellow ground. *Height, 34 inches; width, 17 inches*

[See illustration]

19

110. PAIR DIRECTOIRE CARVED WALNUT AND TAUPE SILK FAUTEUILS
French, Late XVIII Century

Pleasing neo-classic model with flaring rectangular back, curved arms, swelled (or bowed) seat, and nicely turned front posts and supports. Back and seat covered in taupe silk, patterned with a small floral motive in green and silver.

[See illustration]

111. PAIR DIRECTOIRE CARVED WALNUT AND TAUPE SILK FAUTEUILS
French, Late XVIII Century

En suite with the preceding.

112. DIRECTOIRE CARVED WALNUT AND TAUPE SILK CANAPÉ
French, Late XVIII Century

En suite with the preceding.
Length, 6 feet

[See illustration]

113. RÉGENCE CARVED WALNUT AND GREEN DAMASK BANQUETTE
French, XVIII Century

Wall bench with long rectangular top, upholstered and covered in green silk damask, the gently undulating frame and cabriole supports carved with leafage.
Height, 17 inches; length, 6 feet 3 inches

114. LOUIS XVI MARQUETERIE DECORATED BACKGAMMON TABLE
French, XVIII Century

Compartmented oblong frame inlaid with checker and backgammon boards; two drawers in the frieze, which is inlaid with gaming cards and dominos in *marqueterie*. Four square tapered supports; lift-off reversible top lined with leather and baize for gaming or writing purposes. Reconditioned.
Height, 29 inches; length, 46 inches

20

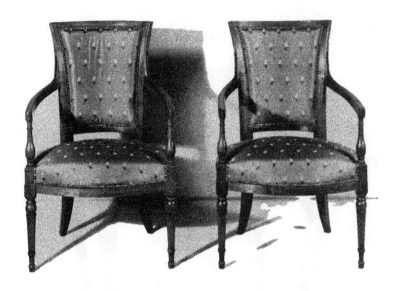

[NUMBER 110]

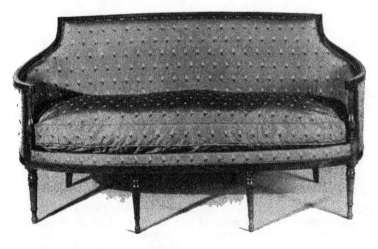

[NUMBER 112]

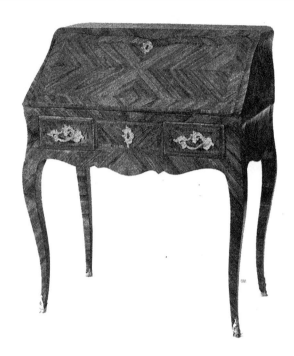

[NUMBER 115]

115. LOUIS XV BOIS DE VIOLETTE BUREAU *French, XVIII Century*
Veneered on all surfaces with handsomely matched panels of rich wood in a herringbone design. The hinged slant front encloses a series of small drawers and compartments arranged in three tiers; in the valanced apron, two small drawers with gilded bronze rocaille handles and escutcheons. Gently curved and tapering legs ending in bronze shoes. Reconditioned. *Height, 38 inches; width 30 inches*

[See illustration]

116. DIRECTOIRE CARVED PAINTED AND GILDED WALL MIRROR
French, Late XVIII Century
Rectangular frame surmounted by a shaped crest composed of foliage volutes, laurel wreath, and musical instruments.
Height, 44 inches; width, 23 inches

22

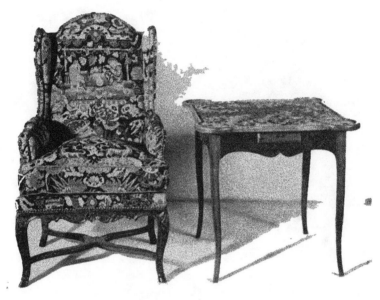

[NUMBER 117] [NUMBER 118]

117. LOUIS XIV CARVED WALNUT AND NEEDLEPOINT WING CHAIR
French, circa 1700

In transitional style, showing the development of the rococo style. Arched and canted back, arms, seat, and seat cushion covered in *petit* and *gros point*, designed with "Teniers" figures, birds, flowers, and animals. The walnut frame and hoof-footed cabriole legs carved with shells and leafage and braced with saltire stretchers.

[See illustration]

118. RÉGENCE FRUITWOOD AND NEEDLEPOINT CARD TABLE
French, XVIII Century

Square top with outcurved corners covered with wool *gros point* in a baroque leaf-scroll design in green and white. Four small drawers around the valanced frieze; gently curved and tapered supports.
Height, 27 inches; width, 29 inches

[See illustration]

23

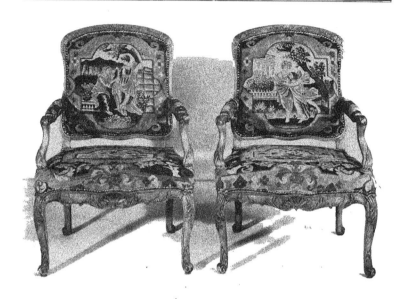

[NUMBER 119]

119. PAIR RÉGENCE CARVED WALNUT AND NEEDLEPOINT FAUTEUILS

French, XVIII Century

650 — Shaped back, seat, and armpads covered in *petit* and *gros point* designed with mythological figure subjects and birds, in cartouches framed in flowers and scrolls. The frames and cabriole supports carved with shells and foliage.

[See illustration]

120. DIRECTOIRE ACAJOU TABLE À ROGNON
MOUNTED IN BRONZE DORÉ *French, Late XVIII Century*

150 The shaped top bordered with a pierced gilded bronze gallery and supported on grooved uprights at each end connected by an elongated oval shelf and having splayed trestle feet.

Height, 30 inches; length, 43½ inches

24

121. LOUIS XVI INLAID KINGWOOD CABINET *French, XVIII Century*
Wall cabinet of rectangular form, with two doors enclosing shelves.
Top, front, and sides veneered with matched panels of kingwood.
170 — *Height, 35 inches; width, 32 inches*

122. RÉGENCE INLAID KINGWOOD COMMODE MOUNTED IN BRONZE DORÉ
 French, XVIII Century
Serpentine front contains three drawers with elaborate gilded bronze
handles and escutcheons. Front and sides veneered with matched
110 — panels of dark kingwood; top covered with a slab of *fleur de pêche*
marble. *Height, 32 inches; length, 38 inches*

123. RÉGENCE INLAID KINGWOOD COMMODE MOUNTED IN BRONZE DORÉ
 French, XVIII Century
Gently serpentined front with four drawers veneered and banded with
light and dark kingwood and ornamented with elaborate gilded bronze
170 — handles and escutcheons. Returns hollow-fluted; top covered with a
slab of *fleur de pêche* marble. *Height, 33 inches; length, 51 inches*

124. LOUIS XV CARVED, LAQUÉ, AND CANNÉ FAUTEUIL
 Jacques Brocsolle (M.M.1743); French, XVIII Century
Shaped back and seat filled with cane; voluted and molded frame
carved with flowers and leaves on the crest, skirt, and knees and
painted white. Stamped J. BROCSOLLE, under the seat. With blue
damask cushion.
170 — *Note:* Jacques Brocsolle passed master in 1743 and had his establishment
 in the Faubourg St. Germain, by the entrance of the Rue des Postes, where he
 carried on a large business and died in 1763.

125. LOUIS XV CARVED, PAINTED, AND CANNÉ FAUTEUIL
 French, XVIII Century
A chair of somewhat similar design to the preceding, but slightly
larger, with white frame and blue damask seat cushion. An unde-
00 — cipherable *ébéniste* stamp appears under the frame.

126. LOUIS XVI CARVED AND GILDED CONSOLE *French, XVIII Century*
Semicircular top covered with a slab of white marble, the frieze and
fluted round supports carved with guilloche and leafage, the incurvate
stretcher embellished with an urn hung with swags of flowers.
Height, 34½ inches; length, 39 inches

[See illustration]

127. LOUIS XVI CARVED AND LAQUÉ LIT DE REPOS
IN GOLDEN YELLOW SILK *French, XVIII Century*
Long couch in the classic taste, probably from the atelier of Georges
Jacob, with rising and slightly flaring ends; eight fluted and tapered
round legs. The molded frame carved with small rosettes and lac-
quered white. Covered in old silk; loose mattress and two bolster
pillows. *Length, 6 feet 3 inches; width, 31 inches*

[See illustration]

128. LOUIS XVI CARVED, LAQUÉ, AND GILDED TRUMEAU
French, XVIII Century
Mirror glass framed with gilded moldings, while above this is a group
of trophies of the harvest, gilded, on a white ground.
Height, 41 inches; width, 25 inches

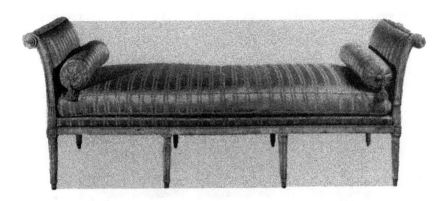

[NUMBER 127]

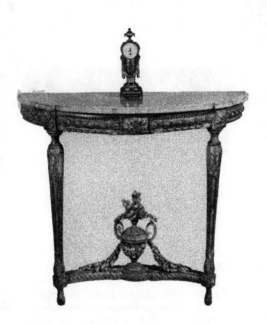

[NUMBER 126]

BRONZE DORÉ PENDULE: NUMBER 80

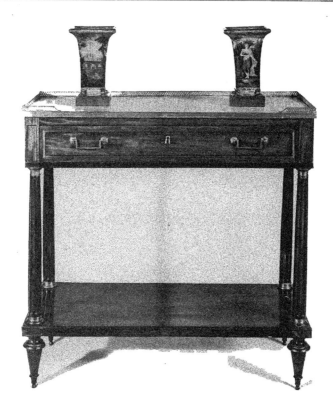

[NUMBER 129]

CHARLES X TOLE URNS: NUMBER 26

129. LOUIS XVI ACAJOU BUFFET TABLE MOUNTED IN BRONZE DORÉ
French, XVIII Century

Oblong top of white marble guarded by a pierced bronze gallery; the frieze paneled with bronze moldings and containing a drawer. The fluted round tapering supports braced by an undershelf and terminating in peg feet. *Height, 36 inches; length, 38 inches*

[See illustration]

28

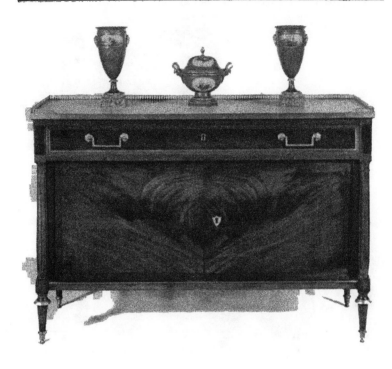

[NUMBER 130]

EMPIRE TOLE GARNITURE: NUMBER 38

130. LOUIS XVI ACAJOU COMMODE MOUNTED IN BRONZE DORÉ

French, XVIII Century

Commode or buffet in the late style of Riesener. Straight front enclosed by two doors of handsomely figured wood and, above these, a long drawer, while at either corner of the body are hollow fluted pilasters extended into tapered baluster short legs. Front and supports enriched with gilded bronze moldings and handles, the white marble top guarded by a pierced bronze gallery.

Height, 35 inches; length, 51 inches

[See illustration]

29

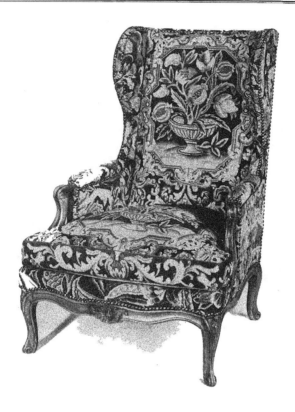

[NUMBER 131]

131. LOUIS XIV CARVED WALNUT AND NEEDLEPOINT WING CHAIR

French, circa 1700

A winged low armchair covered in *petit* and *gros point* designed with urns of pomegranates and flowers, in cartouches framed with foliage and scrolls. Molded cabriolet frame and supports carved with leafage on the skirt and knees. Loose seat cushion in needlepoint.

[See illustration]

132. LOUIS XVI WALNUT MARQUETERIE COMMODE
Southern French, XVIII Century

Rectangular, with two drawers in front and square tapering legs. The front inlaid with neo-classic ornament in light woods; top covered with repaired slab of white marble. *Height, 33 inches; length 33 inches*

133. RÉGENCE CARVED WALNUT AND BROCADE SIDE CHAIR
French, XVIII Century

Shaped back and seat upholstered and covered in contemporary rose pink and gold flowered brocade, the light walnut frame and supports handsomely carved with leafage and flowers.

134. LOUIS XV CARVED AND CANNÉ WALNUT CANAPÉ
French, XVIII Century

The shaped back and seat filled with cane; the gently serpentined crest rail, valanced skirt, and knees of the cabriole supports carved with groups of flowers, laurel sprays, and ribbon motives. Seat furnished with loose cushion in celadon green silk. *Length, 7 feet 10 inches*

135. DECORATIVE PAINTING IN OILS *French School, XVIII Century*

Two maidens with flowers, a gallant, and a child in Louis XV costumes, before a group of trees beside a lake.
Height, 43½ inches; width, 30 inches

136. DECORATIVE PAINTING IN OILS: DESSUS-DE-PORTE *French School*

Harbor scene, with square-rigged ships upon the blue water, figures by the foreground shore, and ruins at the left. In the manner of Claude Vernet. *Height, 21 inches; length, 49¼ inches*

137. PAIR DIRECTOIRE CARVED AND LAQUÉ DESSUS-DE-PORTES
French, Late XVIII Century

Overdoor panels beautifully carved in white relief with figures of Venus and Leda in chariots drawn by dolphins and swans and attended by amors, in a yellow ground.
Height, 16½ inches; length, 5 feet 6 inches

31

138. LOUIS XVI INLAID KINGWOOD SECRÉTAIRE À ABATTANT

French, XVIII Century

2 5 0 —

Rectangular cabinet with hinged let-down writing desk lined with leather and enclosing fitted interior; two doors above and below, enclosing shelves. Front and sides diagonally veneered with *citronnier* wood in borders of kingwood; the returns inlaid with mock fluting. Gray Ste Anne marble top.

Height, 5 feet 3 inches; width, 38½ inches

[See illustration]

139. LOUIS XVI CARVED, LAQUÉ, AND GILDED TRUMEAU

French, XVIII Century

175

Rectangular overmantel, the mirror glass framed with gilded molding and, above this, swags of flowers and amatory trophies depending from ribbon knots. Flanking the glass, rams'-mask *flambeaux* emitting two branches for candles. The ornament in gilded relief in a green ground.

Height, 5 feet 6 inches; width, 5 feet 9 inches

140. LOUIS XVI DECORATED CHINOISERIE LACQUER CABINET

French, XVIII Century

375

Front enclosed by two lacquered doors with drawer above and painted and gilded with Chinese landscape containing pavilion and figures; the sides with panels of birds and flowers. Marble top repaired.

Height, 58 inches; width, 44 inches

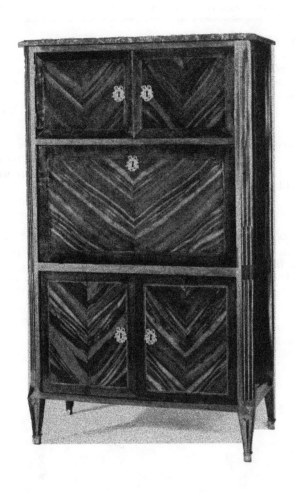

[NUMBER 138]

141. LOUIS XVI CARVED, LAQUÉ, AND PARCEL-GILDED TRUMEAU
WITH OIL PAINTING *French, XVIII Century*
Laqué celadon, with Louis XVI carved and gilded details; oblong
mirror, surmounted by an oil painting of rustic lovers in the style of
Boucher within a bowknotted gilded frame.
Height, 5 feet 3 inches; width, 50 inches

142. DIRECTOIRE BRASS INLAID KINGWOOD BOOKCASE
French, XVIII Century
The front enclosed by two wire-grilled doors, the frames of which are
inlaid with brass in an interlaced design.
Height, 6 feet 9 inches; width, 42 inches

143. DIRECTOIRE CARVED AND LAQUÉ BEDSTEAD
French, Late XVIII Century
The high rectangular ends composed of spiral-fluted pilasters; horizon-
tal frieze carved with an urn and sprays of laurel and lacquered soft
white and blue. *Length, 6 feet 6 inches; width, 46 inches*

144. BLACK AND GOLD LACQUER TABOURET
Circular top painted and gilded with flowers and birds, on four in-
curved supports. *Height, 13 inches; diameter, 22 inches*

[END OF FIRST SESSION]

34

SECOND AND LAST SESSION

Saturday, January, 30, 1937, at 2 p. m.

CATALOGUE NUMBERS 146 TO 284 INCLUSIVE

FRENCH ENGRAVINGS AND DRAWINGS

146. SEPIA DRAWING *French School, XVIII Century*
A youth, a maiden, and a child about a table, playing a game with dice, the maiden leaning against a chair. Signed with initials s.c., and dated 1750. Together wth a small colored portrait engraving of Louis XVI.
Height, 5¼ inches; length, 6¼ inches

147. LINE ENGRAVING *L. Surugue, after Watteau*
Le Joueur de Guitar. Small folio. Gilded frame.

148. ENGRAVING IN THE CRAYON MANNER *Demarteau, after Boucher*
Nymph Bathing, from the Porte-feuille de Mr. Nera. Small folio, oval, printed to simulate plumbago and sanguine. Gilded frame.

149. COLORED ENGRAVING *L. Sailliar, after Cosway*
His Royal Highness William Henry, Duke of Clarence. Small folio, with titles; pub'd 1790. Gilded frame.

150. THREE LINE ENGRAVINGS *De Larmessin, after Boucher and Lancret*
La Courtisanne Amoureuse, Les Remois, and A Femme Avare Galant Escroc. Folios, good impressions, with full margins. Gilded frames.

151. TWO LINE ENGRAVINGS *De Larmessin, after Lancret*
Le Petit Chien Qui Secoue de L'Argent et des Pierreries, and La Servante Justifiée. Folios, good impressions, with full margins. Gilded frames.

152. PAIR LINE ENGRAVINGS *Ingouf, after Freudeberg, 1770*
Le Soldat en Semestre and Le Négociant Ambulant. Medium folios, fine impressions, with titles. Gilded frames.

153. SET OF FIVE LINE ENGRAVINGS
J. B. Patas, and others, after Fragonard
Romantic and genre subjects. Small folios, fine impressions. Gilded frames.

35

154. Line Engraving *Baron, after Watteau*

30- L'Amour Paisible. Folio, good margins, full titles in French and Latin. Gilded frame.

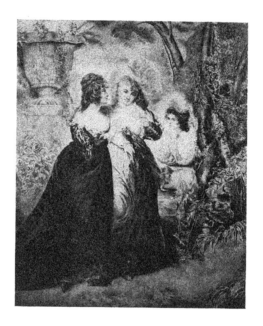

[NUMBER 155]

155. Drawing on Parchment

Rev. M. W. Peters, R.A., British: 1749-1814

220- From "Much Ado About Nothing", Act III, Scene I. Hero and Ursula, with arms linked, discoursing in the foreground, one in black gown, the other in rose and saffron, with large plumed red hat; at the right, Beatrice is listening behind the shrubbery.

Crayon, India wash, and watercolor: Height, 20¼ inches; width, 17 inches

[See illustration]

36

156. THREE COLORED ENGRAVINGS *After Carle Vernet*
Directoire genre subjects, signed in the plate by the artist. Folios, margins trimmed.

157. LINE ENGRAVING *A. J. Duclos, 1779*
The Court of Marie Antoinette. Folio, good impression, proof before letters; engr. in Paris, 1779. Gilded frame.

158. STIPPLE ENGRAVING IN COLORS *Coqueret, after Rigaud*
J. de La Fontaine. Medium folio, printed in colors; good impression with full title. Gilded frame.

159. ENGRAVING IN THE CRAYON MANNER *After Lambert*
Landscape with View of a Mill. Medium folio, proof before letters. Gilded frame.

160. LINE ENGRAVING *Ravenet, after Pater*
L'Orquestre de Village. Folio, good impression, with title and stanza. Gilded frame.

161. PAIR LINE ENGRAVINGS *De Larmessin, after Boucher*
Le Magnifique and Le Fleuve Scamandre. Folios, fine impressions, with full titles and margins. Gilded frames.

162. LINE ENGRAVING *G. Scotin, after Pater, 1731*
Arrivée de L'Operateur a L'Hostellerie. Folio, good impression, with margins and full title. Gilded frame.

163. LINE ENGRAVING *Belechou, after Jeaurat, 1743*
Le Mari Jaloux. Folio, good impression, with full margins and title with stanza. Gilded frame.

164. LINE ENGRAVING *Beauvarlet, after Drouais fils*
The Guitar Player. Folio, with full margins, slightly foxed. Gilded frame.

165. STIPPLE ENGRAVING IN COLORS *J. P. Simon, after Le Roy*
L'Amitié. Medium folio, fine impression, with full margin and title. Gilded frame.

37

166. STIPPLE ENGRAVING PRINTED IN COLORS

J. Baldrey, after Salvatore Rosa

80- The Finding of Moses. Folio, brilliant impression, with full title; pub'd by Jno. Boydell, London, 1785. Gilded frame.

167. ENGRAVING *Huquier fils, after Boucher*

50- La Fille a L'Oyseau. Medium folio, with good margins and titles. Gilded frame.

168. THREE ENGRAVINGS

65- Louis Quinze, Roy de France, stipple engraving in bistre; The Three Graces, by J. B. Michel, after Rubens, mezzotint; and John Gawler, Aetat. L. Anno MDCCLXXVII, by J. R. Smith, after Reynolds, mezzotint. Framed. [Lot.]

PAINTINGS

JOHN DOWNMAN, R.A.
BRITISH: 1750-1824

169. PORTRAIT OF A GENTLEMAN

15- Profile figure at waist length, facing left, wearing a powdered tie-wig, henna brown coat, striped tan and cream-white waistcoat, and jabot. Oval brown background. *Watercolor: Height, 9 inches; width, 7 inches*

PIETRO LONGHI [SCHOOL OF]
VENETIAN: XVIII CENTURY

170. PORTRAITS OF A LADY AND GENTLEMAN: TWO PAINTINGS

45- Waist-length figures to half left, the lady in a turquoise blue robe, holding a nosegay of flowers, the gentleman in greenish blue coat with frilled jabot and cuffs. *On copper: Height, 6½ inches; width, 5 inches*

FRENCH SCHOOL
Circa 1800

171. PORTRAIT OF A LADY OF THE CONSULATE

75- Waist-length figure to half left of a young lady in a décolleté white gown, her curling brown hair bound with a white bandeau. Brown background. *Height, 12¾ inches; width, 9½ inches*

38

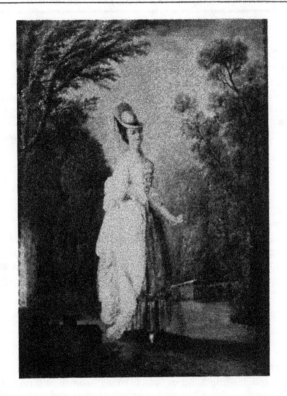

[NUMBER 172]

JEAN FREDERIC SCHALL
FRENCH: 1752-c. 1825

172. A LADY IN A PARK

Full-length figure to half right of a young woman in a white Louis XVI gown with low *décolletage* and *échelle* and high brimmed hat; walking along a path bordered by tall russet and green trees, a deep blue sky appearing above the treetops.

Panel: Height, 13 inches; width, 9¾ inches

[See illustration]

20—

JEANNE PHILIBERTE LEDOUX
FRENCH: 1767-1840

173. PORTRAIT OF A YOUNG GIRL

Head and shoulders portrait of a girl turned to look over her right
shoulder, her smiling face framed by long powdered curls dressed with
a rose bandeau. A décolleté white gown and sapphire blue scarf show
about her shoulder. Greenish gray background.

Height, 16¼ inches; width, 13 inches

/ O O –

SIR GODFREY KNELLER [FOLLOWER OF]
BRITISH: EARLY XVIII CENTURY

174. PORTRAIT OF A LADY

Three-quarter-length figure of a dark-haired young woman seated lean-
ing against a pedestal at the right; she wears a décolleté amber gown
and gray scarf. Draped background, with a landscape vista at the left.

Height, 24 inches; width, 19½ inches

6 O –

BRITISH SCHOOL
EARLY XVIII CENTURY

175. PORTRAIT OF A LADY

Three-quarter-length figure of a young woman wearing an amber
brown gown, with white ruffles at the sleeves and neck, and a dark
gray scarf; seated before a crimson drapery disclosing a twilight
landscape at the left. *Height, 24 inches; width, 21 inches*

6 O –

ROSALBA CARRIERA
VENETIAN: 1675-1757

176. PORTRAITS OF LADIES: TWO PASTEL PAINTINGS

Three-quarter-length graceful figures, one seated to half right, holding
a basket filled with fruit and wearing blue and rose draperies; the
other to half left in sapphire blue mantle, her powdered hair dressed
with flowers and a nosegay held upon her arm. Shaded blue back-
grounds. *Height, 16 inches; width, 13 inches*

3 2 O –

40

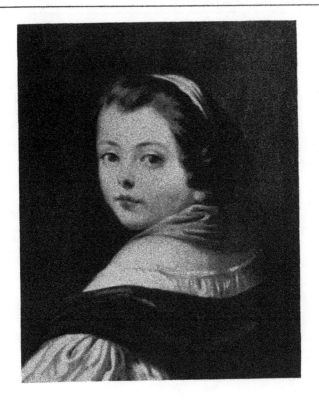

[NUMBER 177]

JACQUES ANTOINE VALLIN
FRENCH: 1760-1831

177. PORTRAIT OF A CHILD, AFTER GREUZE

*H*ead and shoulders portrait of a little girl with soft brown hair bound by a bandeau, turning to look at the observer over her left shoulder; she wears a white chemisette with a saffron kerchief and black shawl. Dark green background.

Height, 18 inches; width, 15 inches

[See illustration]

41

FRENCH SCHOOL
EARLY XVIII CENTURY

178. PORTRAIT OF A GENTLEMAN IN RED COAT

Bust-length figure to half right of a man wearing a powdered tie-wig
and coral red coat and waistcoat, with lace jabot. Tan background.

Pastel: Height, 14¼ inches; width, 11¼ inches

30—

JEAN BAPTISTE GREUZE [FOLLOWER OF]
FRENCH: XVIII-XIX CENTURY

179. GRACE BEFORE MEALS

An interior, with a child in scarlet paniers and white cap standing in
profile, her hands folded, saying grace; before her her young mother
is seated, holding a bowl of porridge upon her aproned knees, with a
workbasket and a wide-brimmed leghorn hat upon the floor at her
side. *Height, 25¾ inches; width, 21¼ inches*

80 —

FRENCH SCHOOL
XVIII-XIX CENTURY

180. TWO PAINTINGS OF CHILDREN, AFTER BOUCHER

One a little girl in Louis XV coral costume dancing with a tambourine;
the other a child carrying a basket of flowers. Before park landscapes.

Height, 25¼ inches; width, 20¼ inches

340—

JEAN RAOUX
FRENCH: 1677-1734

181. LA LEÇON DE MUSIQUE

Depicting two young ladies at half length, holding a sheet of music
between them, the one at the left in a rose pink gown and blue mantle,
beating time to the music with a roll, the one at the right singing and
looking toward the observer, wearing a gray bodice and slashed rose
sleeves, her face framed by a small ruff and plumed hat. Dark back-
ground. *Height, 42½ inches; length, 59½ inches*

250—

[See illustration]

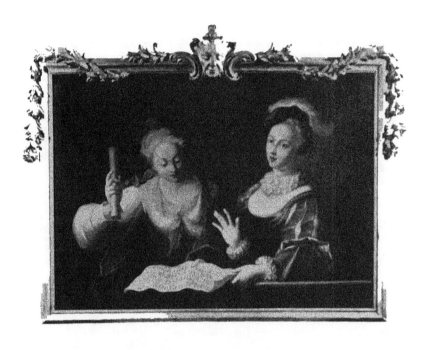

LA LEÇON DE MUSIQUE: NUMBER 181

Jean Raoux

SIR THOMAS LAWRENCE, P.R.A.
BRITISH: 1769-1830

182. LE DUC DE BORDEAUX

Half-length figure of a boy with fresh complexion and clear blue eyes, wearing a dark blue and gray naval dress uniform and holding a cutlass in the bend of his left arm. Background of dark clouds opening to a patch of blue at the left. *Height, 30 inches; width, 25 inches*

Henri Charles Ferdinand Marie Dieudonné, Comte de Chambord, Duc de Bordeaux (1820-1883), the "King Henry V" of the French Legitimists, son of the Duc de Berri and the Princesse Caroline Ferdinande Louise of Naples, and grandson of Charles X. After the revolution and abdication of Charles X, he was proclaimed king, but was forced to follow his grandfather into exile. In July, 1871 he again publicly posed as King and-again had to quit France. Two more attempts were made to place him on the throne, 1873 and 1874, but his persistent adherence to the principles of Divine Right cost him the crown. He died at Frohsdorf, August, 1883.

The portrait was probably painted in the autumn of 1825, when Lawrence was sent on a commission from George IV to paint the portrait of Charles X in Paris. During the sittings, the children of the Duchesse de Berri were playing in the studio. (See Armstrong, *Lawrence,* 1913, p. 90)

[See illustration]

ALEXANDRE FRANÇOIS DESPORTES [SCHOOL OF]
FRENCH: XVIII CENTURY

183. HUNTING SCENE

Depicting six youths gathered about a hunt breakfast, before an undulating and distant landscape. In the foreground, a hound approaches a stream to drink; beyond him, dead game is laid beside a gun.

Height, 44 inches; width, 36¼ inches

44

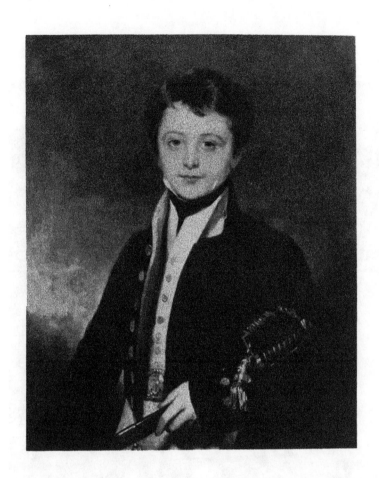

LE DUC DE BORDEAUX: NUMBER 182

Sir Thomas Lawrence, P.R.A.

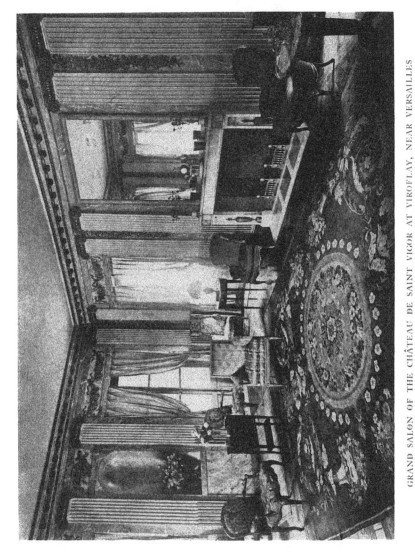

GRAND SALON OF THE CHÂTEAU DE SAINT VIGOR AT VIROFLAY, NEAR VERSAILLES

FRENCH XVIII CENTURY FURNITURE
AND DECORATIONS

184. LOUIS XVI BLANC DE CHINE PORCELAIN COUPE
MOUNTED IN BRONZE DORÉ

Lotus-shaped small bowl with prunus and lotus branches in relief;
gilded bronze rim, handles, and base. *Height, 4 inches*

185. LOUIS XV INLAID TULIPWOOD PERFUME CASKET
Richly veneered and inlaid; mounted in gilded bronze.
Height, 7½ inches

186. DIRECTOIRE SILVERED BRONZE WRITING SET *French, circa 1800*
Comprising cylindrical ink pot, with attached pen holder, and two
smaller pots with covers, one with glass liner.
Heights, about 4½ inches

187. LOUIS PHILIPPE INLAID AMBOYNA WOOD LIQUEUR CASE
French, XIX Century
In the Louis XVI taste, with hinged front and top, handsomely inlaid
with various woods and containing etched glass decanters and goblets.
Height, 9½ inches; length, 15 inches

188. PAIR STRASBOURG FAÏENCE JARDINIERES *Early XIX Century*
In the form of miniature commodes; painted with birds and legends in
cobalt and yellow. *Length, 9½ inches*

189. MARSEILLES DECORATED FAÏENCE SOUPIÈRE AND STAND
XVIII Century
Painted with sprigs and borders of foliage and flowers in orange and
green; cover with fruit finial. *Length, 15 inches*

190. CHINESE DECORATED PORCELAIN VASE FITTED AS LAMP *Wan Li*
Painted in iron red and green and fitted for electric light; with *écru*
silk shade. *Height, 7½ inches*

191. DIRECTOIRE BRONZE DORÉ SMALL CLOCK
Rectangular case chased with acanthus and formal foliage, on four
lion-paw feet. The dial inscribed *F. Schmid.* *Height, 9 inches*

47

192. PAIR LOUIS XVI BRONZE DORÉ CHENETS *French, XVIII Century*
140 — Pleasing pair, of balustrade form, *plaqué* with rosettes and embellished
with acorn-shaped finials. *Height, 7 inches*

193. EMPIRE BRONZE AND BRONZE DORÉ PENDULE À BORNE
Mugnier, Paris, Early XIX Century
110 — Of milestone form, garlanded with a grapevine and surmounted by a
tazza; octagonal base of white marble. Dial inscribed *Mugnier H. De
Monsier Friér Duroi.* *Height, 16 inches*

[See illustration on page 70]

194. PAIR GLAZED POTTERY FIGURES OF LIONS *Ming*
130 — Fantastic animal in white porcelaneous ware glazed turquoise blue, iron
red, and yellow; representing the male and female, the first with front
paw resting on a sphere, the second accompanied by a cub. Rectangular
plinths decorated with panels of flowers of the seasons. Few small
repairs. *Height, 21 inches*

[See illustration of one, on page 56]

195. THREE CHINESE PAINTINGS ON GLASS
90 — A pair depicting legendary combats; another an emperor with atten-
dants, in a pavilion. *Height, 14 inches; length, 20 inches*

196. PAINTED KETTLE-DRUM OF THE FRENCH REVOLUTION *Circa 1790*
20 — Painted with furled flags, a Liberty cap, and *Liberté et Egalité.*
Height, 12 inches

197. LOUIS PHILIPPE NEEDLEPOINT LOW STOOL *French, XIX Century*
30 — Square top covered in red and black needlepoint with *chinoiseries,* on
carved short legs.

198. EMPIRE PETIT POINT FOOTSTOOL *French, Early XIX Century*
40 Oblong top in *petit point* designed with an urn in light blue ground, on
four *bronze doré* lion paw feet.

199. ACAJOU BED TRAY *French, circa 1810*
30 — Oblong tray on four turned short legs; fitted with adjustable book
rest. *Length, 25 inches*

48

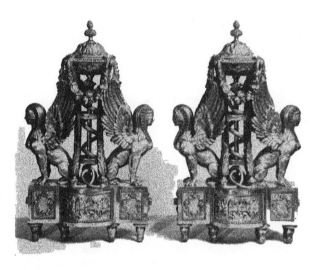

[NUMBER 200]

200. PAIR LOUIS XVI BRONZE DORÉ CHENETS *French, XVIII Century*
Composed of a classic urn on hoof feet, garlanded with flowers and
flanked by two Egyptian winged sphinxes, surmounting a shaped ob-
long plinth, *plaqué* with flowers and ribbon knots. *Height, 23 inches*

[See illustration]

3γ0-

201. LOUIS XV LAQUÉ AND PARCEL-GILDED BRACKET CLOCK
French Rococo
Cartouche-shaped case lacquered with *chinoiserie* and flowers in a soft
white ground and decorated with gilded husk swags, strapwork, and
other ornamentation. *Height, 28 inches; width, 15 inches*

40-

202. LOUIS XVI CUT CRYSTAL CHANDELIER *French, XVIII Century*
Of *ballon* form, composed of festoons of faceted crystal beads sus-
pended on a circular frame and small canopy; wired for eight electric
lights. *Height, 36 inches; diameter, 17 inches*

145

49

203. LOUIS XV CARVED WALNUT AND NEEDLEPOINT STOOL

French, XVIII Century

95 -

Shaped oblong top covered in *pavot* needlework; frame and cabriole supports carved with shells and leafage.

204. LOUIS XV CARVED AND CANNÉ BEECHWOOD CHILD'S CHAIR

Shaped back and seat filled with cane, molded and carved frame and

50 - supports.

205. LOUIS XVI CARVED FRUITWOOD TABLE DE CHEVET

French, XVIII Century

100-

Small bedside table with pierced sides, open front, one drawer, and tapering curved supports; gray Ste Anne marble top.

Height, 29½ inches; width, 17 inches

206. WHITE PAINTED FAUTEUIL BONNE FEMME IN PETIT POINT

French, XVIII Century

450-

The back and seat cushion and arms covered in *petit point* designed with a bold floral pattern in red in a white ground; furnished with side pockets to hold sewing requisites.

207. DIRECTOIRE ACAJOU AND NEEDLEPOINT FIRE SCREEN

French, circa 1800

130-

Rectangular *cheval* screen framing a rising panel of *petit point* designed with an urn of flowers in a white ground.

Height, 35 inches; width, 23 inches

208. PAIR LOUIS XVI CARVED WALNUT AND

SILK BROCADE CHAUFFEUSES *French, XVIII Century*

260-

Low side chair with oval back and shaped seat in silk brocade with a *fleurette* and trellis pattern; on short round fluted and tapering legs, the dies carved with leaf medallions.

209. LOUIS XV DECORATED LAC PETITE COMMODE *Venetian Rococo*

75-

Small cabinet with tray top and tapered and curved short legs; front with four doors enclosing a cupboard and four small drawers. Interior decorated with *chinoiserie* in a blue ground, the exterior with similar motive in black and gold. *Height, 27½ inches; width, 17½ inches*

50

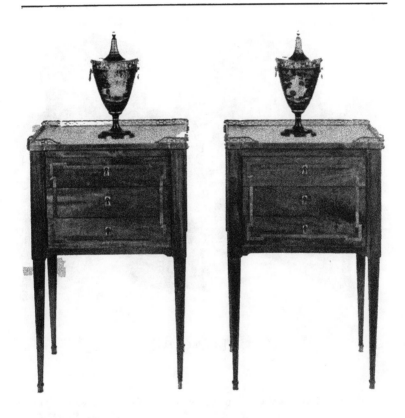

[NUMBER 210]

DIRECTOIRE TOLE URNS: NUMBER 30

210. PAIR LOUIS XVI ACAJOU PETITES COMMODES
MOUNTED IN BRONZE DORÉ *French, XVIII Century*
Small rectangular three-drawer commode on square tapered legs; white
marble top bordered with a bronze gallery. The front decorated with
inlaid brass bandings in gadroon effect.
Height, 30½ inches; width, 20 inches

[See illustration]

51

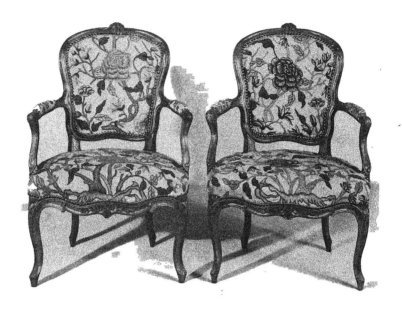

[NUMBER 211]

211. PAIR LOUIS XV CARVED WALNUT AND NEEDLEPOINT FAUTEUILS

French, XVIII Century

Pleasing small chair, the molded frame and cabriole supports carved with small clusters of leaves and flowers on the crest, the knees, and the skirt. Shaped back, seat, and arms covered in needlepoint designed with flowers in a light ground.

[See illustration]

212. PAIR LOUIS XV CARVED WALNUT AND NEEDLEPOINT FAUTEUILS

French, XVIII Century

En suite with the preceding.

52

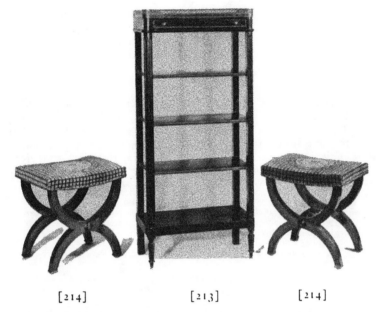

[214] [213] [214]

213. LOUIS XVI ACAJOU FIVE-TIER ÉTAGÈRE
 MOUNTED IN BRONZE DORÉ *French, XVIII Century*
 Stand for books or *bibelots* composed of five shelves and grooved up-
 rights; the top shelf containing a drawer and guarded by a pierced
 bronze gallery. *Height, 49 inches; width, 22 inches*
 [See illustration]

214. PAIR EMPIRE ACAJOU AND PAINTED VELOURS BANQUETTES
 French, Early XIX Century
 Oblong top covered in velours painted with an Empire medallion mo-
 tive in a blue checkered ground; on X-shaped supports with turned
 medial brace.
 [See illustration]

215. DIRECTOIRE FRUITWOOD SMALL WORK TABLE *French, circa 1800*
 With octagonal tray top, one side of which is hinged; on trestle-shaped
 supports, braced with an undershelf. Enriched with *cuivre doré* mold-
 ings. *Height, 27 inches; width, 20 inches*

53

216. DIRECTOIRE WHITE LAQUÉ AND NEEDLEPOINT FAUTEUIL
French, Late XVIII Century

180-

Flaring rectangular back, curved arms, and turned front posts. Back, seat, and armpads, in *petit point* designed with flowers in a light ground.

217. PAIR LOUIS XV CARVED WALNUT AND PETIT POINT DE ST CYR FAUTEUILS *French, XVIII Century*

550

The back and seat covered in very fine silk and wool *petit point* illustrating episodes from the tale of Don Quixote, in shaped cartouches bordered with garlands of flowers and strapwork, in a soft green-yellow ground. The molded cabriolet frame carved with small groups of flowers and leaves on the crest, the knees, and the skirt.

> *Note:* This pair of *fauteuils* and the companion pair [Number 218] comprise a set of four of exceptional quality covered in the rare *petit point de St Cyr*, worked with episodes from Cervantes' *Don Quixote,* a subject rarely encountered in French needlepoint furniture. The present pair bear a partly legible stamp, probably that of Pierre-Martin-Dominique Boissier. The two following chairs bear the stamps of Pierre Malbert (M.M. 1765) and of Noël-Toussaint Porrot (M.M. 1761)

[See illustration]

600 218. PAIR LOUIS XV CARVED WALNUT AND PETIT POINT DE ST CYR FAUTEUILS *French, XVIII Century*
En suite with the preceding.

> See note to the preceding.

[See illustration]

219. LOUIS XVI CARVED AND GILDED CONSOLE *French, XVIII Century*

150

Of *demi-lune* form, the frieze and fluted round tapering legs carved with ribbon-knot and leaf motive and joined by an incurvate stretcher embellished with an urn; white marble top.

Height, 35 inches; width, 30 inches

220. PAIR LOUIS XV CARVED WALNUT AND NEEDLEPOINT FAUTEUILS
French, XVIII Century

300-

Pleasing small cabriolet chairs, the light walnut molded and voluted frame carved with small groups of flowers on the knees, crest and skirt. The shaped back, seat, and armpads covered in *pavot* needlepoint.

54

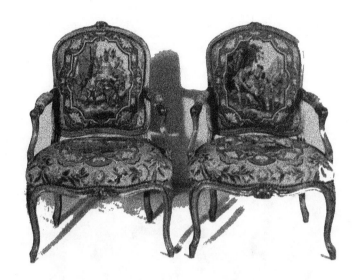

[NUMBER 217]

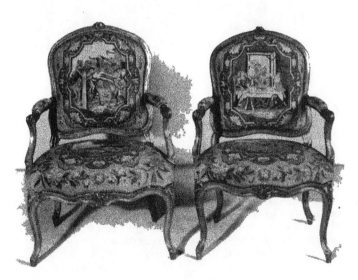

[NUMBER 218]

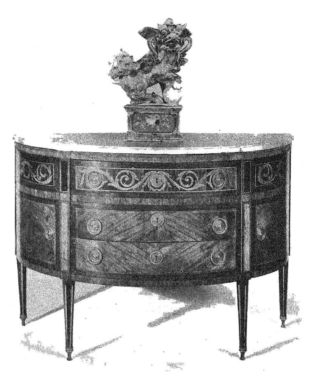

[NUMBER 221]

MING POTTERY LION (ONE OF A PAIR): NUMBER 194

221. LOUIS XVI KINGWOOD MARQUETERIE DEMI-LUNE COMMODE

French, XVIII Century

Of semicircular form, the front containing three drawers flanked by cupboards, with a drawer above; handsomely veneered with matched kingwood inlaid with foliage volutes in light wood *marqueterie*. Dividing the drawers are flat pilasters extended into round tapered legs. Top covered with a slab of *bleu turquin* marble.

Height, 36 inches; length, 52 inches

[See illustration]

56

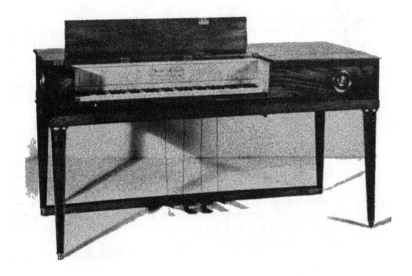

[NUMBER 222]

222. DIRECTOIRE ACAJOU CLAVECIN *Erard Frères, Paris, dated 1802*
Long rectangular case with hinged rising top; the keyboard panel of
nicely figured sycamore inscribed *Erard Frères, Rue du Mail, no. 37, à
Paris*, 1802. Front and ends embellished with *bronze doré rondelles;*
on four round tapering legs with bronze capitals and shoes.
Height, 33 inches; length, 5 feet 5 inches

[See illustration]

223. PAIR LOUIS XV CARVED AND CANNÉ FRUITWOOD COMMODE CHAIRS
French, XVIII Century
Shaped back and hinged seat filled with cane; deep apron on three
sides carved with flowers; gently curved tapering legs similarly carved.

57

224. LOUIS XV TULIPWOOD MARQUETERIE WORK
TABLE MOUNTED IN BRONZE DORÉ *French, XVIII Century*
Oval top of *bleu turquin* marble guarded by a pierced bronze gallery;
a drawer in the frieze. Four gently curved and tapered supports
5/0 — terminating in gilded bronze feet. The frieze and supports inlaid with
urn and floral *marqueterie* in various rich woods. With restorations.
Height, 28½ inches; width, 20 inches

225. LOUIS XVI INLAID TULIPWOOD SECRÉTAIRE À ABATTANT
French, XVIII Century
Rectangular standing cabinet with let-down writing flap in front lined
with leather and enclosing small drawers and compartments; above
300 — this, a shallow drawer and, below, two doors. Front and sides veneered
with panels of tulipwood in borders of kingwood and inlaid with
bandings of light and dark woods..Returns enriched with gilded bronze
mounts. Gray Ste Anne marble top.
Height, 56 inches; width, 31 inches

226. PAIR LOUIS XV CARVED WALNUT AND NEEDLEPOINT FAUTEUILS
Pierre Laroque (M.M. 1766); French, XVIII Century
600 — Beautiful pair of cabriolet chairs, the molded and voluted frames
carved with small clusters of flowers and leaves on the crest, the skirt,
and the knees; backs and seats covered in *petit* and *gros point* designed
with figures of ladies and gallants and groups of animals and birds in
cartouches framed in flowers and scrolls. Frames stamped LAROQUE.

Note: The present pair of *fauteuils*, together with the two following pairs
and the *canapé*, constitute an important *suite* of the Louis XV period, the *fauteuils*
in needlepoint, the *canapé* in silk lampas. The frames are the work of the
maître menuisier Pierre Laroque, who had his establishment in the rue Saint-
Nicolas, and of the *maître menuisier* Noel Boudin, also established in the rue
Saint-Nicolas.

[See illustration]

227. PAIR LOUIS XV CARVED WALNUT AND NEEDLEPOINT FAUTEUILS
Pierre Laroque (M.M. 1766); French, XVIII Century
600 - *En suite* with the preceding. Frames stamped LAROQUE.
See note to the preceding.

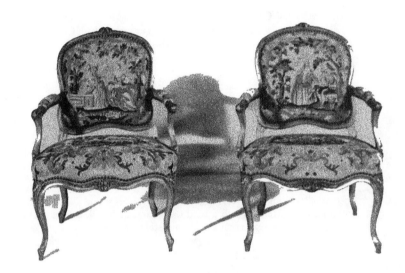

[NUMBER 226]

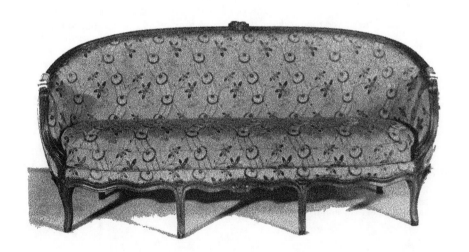

[NUMBER 229]

228. PAIR LOUIS XV CARVED WALNUT AND NEEDLEPOINT FAUTEUILS
Noël Boudin (M.M. 1763); French, XVIII Century
En suite with the preceding. Frames stamped BOUDIN.

600—

See note to Number 226.

229. LOUIS XV CARVED WALNUT AND IVORY SILK CANAPÉ
Pierre Laroque (M.M. 1766); French, XVIII Century
En suite with preceding *fauteuils*. Graceful model of *confidante* type, the molded crest rail extended into sloped, incurved, and voluted arms; gently undulating seat frame and tapered short legs. Frame carved with small groups of flowers and leaves on the crest and skirt. Covered in ivory silk patterned with a bold trellis and flower design in maroon and green; loose seat cushion. Frame stamped LAROQUE.

370—

Length, 7 feet

See note to Number 226.

[See illustration on preceding page]

230. LOUIS XV FRUITWOOD TABLE À ROGNON
Pierre Migeon; French, Early XVIII Century
The curved top bordered with narrow beading and with a hinged book-rest on strut at the centre, flanking which, two rising flaps revealing compartments. On four tapering gently curved supports.

150—

Height, 28 inches; length, 42 inches

231. LOUIS XIV CARVED WALNUT AND NEEDLEPOINT BERGÈRE
French, circa 1700
Winged armchair covered in partly restored *petit* and *gros point* designed with cartouches of flowers and fruits in a white ground, surrounded with a floral trellis motive in colors in a brown ground. Walnut cabriolet supports and seat frame carved with shells and foliage. Seat cushion in needlepoint.

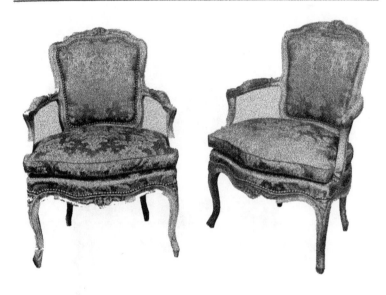

[NUMBER 232]

232. PAIR LOUIS XV CARVED WALNUT AND GREEN SILK DAMASK
FAUTEUILS *French, XVIII Century*
Molded and voluted frame and support carved with small clusters of
flowers and leafage on the crest, the skirt, and the knees. Shaped back
and seat, armpads and seat cushion in emerald silk damask.

[See illustration]

400—

233. PAIR LOUIS XV CARVED WALNUT AND GREEN SILK DAMASK
FAUTEUILS *French, XVIII Century*
En suite with the preceding.

420—

61

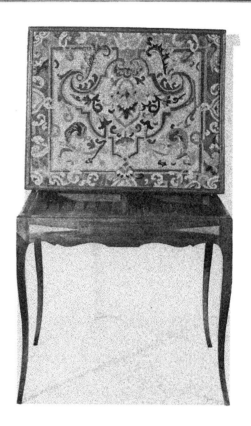

[NUMBER 234]

234. LOUIS XV CARVED FRUITWOOD AND NEEDLEPOINT
TRIC-TRAC TABLE *French, XVIII Century*
Rectangular lift-off top lined with needlepoint and designed with
formalized flower and strapwork cartouches in colors. The compart-
mented frame arranged for backgammon, inlaid in light and dark
woods. Four gently curved and tapered legs and valanced skirt.
 Height, 29 inches; width, 33 inches

[See illustration]

62

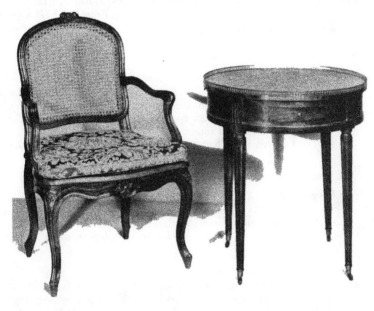

[NUMBER 236] [NUMBER 235]

235. LOUIS XVI ACAJOU BOUILLOTTE MOUNTED IN BRONZE DORÉ
 French, XVIII Century

2 75 Circular table with white marble top guarded by a pierced bronze
 gallery, two drawers and two pull-out slides around the frieze; fluted
 round tapering legs with bronze shoes.
 Height, 29 inches; diameter, 26 inches

 [See illustration]

236. PAIR LOUIS XV CARVED WALNUT AND CANNÉ FAUTEUILS
 French, XVIII Century

260 Shaped back and seat filled with cane; molded and carved frame
 carved with small groups of flowers on the crest, the skirt and the
 knees. Furnished with loose seat cushion.

 [See illustration of one]

237. PAIR LOUIS XV CARVED WALNUT AND CANNÉ FAUTEUILS
French, XVIII Century

2 6 0—

En suite with the preceding.

238. LOUIS XV FRUITWOOD AND NEEDLEPOINT CARD TABLE
French, XVIII Century

/ 0 0—

Overlapping oblong top in needlepoint of later date worked with scattered playing cards and a floral trophy in a green ground. Gently valanced frieze, tapered and curved supports; a small drawer at either end; legs spliced at the bottom. *Height, 30 inches; length, 33 inches*

239. DIRECTOIRE INLAID WALNUT POUDREUSE

4 0—

Square top and flaring sides; interior fitted with a compartmented tray, the hinged lid with a mirror; on flaring supports with undershelf.
Height, 28½ inches; width, 17 inches

240. DIRECTOIRE CERISIER TABLE DE CHEVET *French, circa* 1800

7 0 —

Square pedestal forming a cabinet with mottled gray marble top, on black sphinx-head supports. *Height, 43 inches; width, 14½ inches*

241. LOUIS XV DECORATED LAC COMMODE *Venetian (?) XVIII Century*
Three-drawer rectangular commode, the top, front, and sides painted with *chinoiserie*, birds, flowers, and animals in a yellow ground. With

/ 3 0 —

restorations. *Height, 30½ inches; width, 40 inches*

242. RÉGENCE CARVED WALNUT AND NEEDLEPOINT FAUTEUIL
French, XVIII Century

3 v ✔

Back covered in fine *petit point* designed with Diana and attendants, the seat with group of fantastic animals in a cartouche of flowers, in *petit* and *gros point*. Walnut frame finely carved with shells and leafage on the crest, the arms, the skirt, and the knees of the cabriole legs.

[See illustration]

64

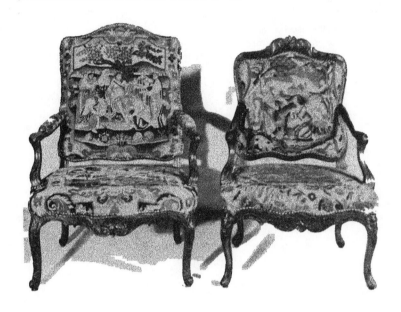

[NUMBER 243] [NUMBER 242]

243. Régence Carved Walnut and Needlepoint Fauteuil.
French, XVIII Century

Shaped back and seat covered in *petit* and *gros point* designed with Apollo and the Muses and groups of birds and animals, in shaped cartouches bordered with flowers and strapwork. The shaped arms, the frame and the cabriole supports carved with shells and foliage. On the back of the seat frame is incised M. DESHOND.

[See illustration]

244. LOUIS XV CARVED, LAQUÉ AND PARCEL-GILDED TRUMEAU
WITH OIL PAINTING *French, XVIII Century*

/50— *Laqué* celadon, ornamented with Louis XV carved and gilded details
and comprising a square mirror surmounted by a decorative painting
depicting a youth and maiden dancing in a park, in the manner of
Lancret, within a rococo gilded frame.

Height, 5 feet; width, 49 inches

[See illustration]

245. RÉGENCE CARVED WALNUT PIER TABLE

French, Early XVIII Century

600— Shaped top of soft dove gray and white marble on gently voluted,
molded, and carved frieze and cabriole supports.

Height, 29½ inches; length, 53 inches

[See illustration]

CLAUDE-MICHEL (CLODION) [ATTRIBUTED TO]
FRENCH: 1738-1814
[Gilded Bronze Statuette]

200— 246. INFANT SATYR

A chubby-cheeked seated infant with cloven hoofed feet and pointed
ears, holding a bunch of grapes to its mouth and seated on a tree
stump. *Height, 24 inches*

[See illustration]

247. LOUIS XV CARVED WALNUT FAUTEUIL IN PETIT POINT

French, XVIII Century

220— With molded and carved cabriolet frame; back and seat in *petit point*
designed with *chinoiserie* in mulberry red and white.

66

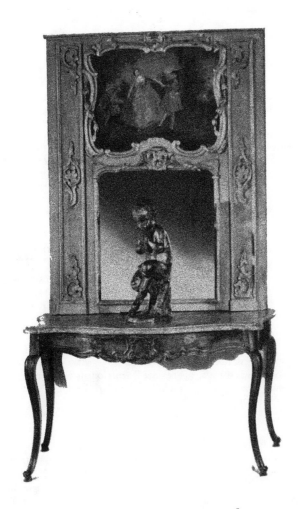

[NUMBERS 244 TO 246 INCLUSIVE]

248. LOUIS XVI ACAJOU SECRÉTAIRE À ABATTANT
French, XVIII Century

300—

Fall-front writing cabinet in the late style of Riesener. The let-down front encloses a series of small drawers and compartments; above this is a drawer, while below are two doors enclosing shelves. The front is paneled with gilded bronze moldings and the styles are also enriched with beading simulating fluting. Gray Ste Anne marble top guarded by a pierced bronze gallery; short turned legs mounted in *bronze doré*.

Height, 58 inches; width, 37 inches

[See illustration]

210

249. LOUIS XV CARVED WALNUT FAUTEUIL IN PETIT POINT
French, XVIII Century

Molded and carved light walnut frame of good design; the back, seat, and armpads covered in *petit point* of later date designed with *chinoiserie* in red and white.

140

250. FRUITWOOD FAUTEUIL BONNE FEMME *French, XVIII Century*

With four shaped slats, abbreviated arms on nicely turned balusters, and spindle bracing all around below the seat. Back and seat furnished with cushions in green silk damask.

200—

251. SET OF FOUR RÉGENCE CARVED WALNUT AND PLUM VELOURS SIDE CHAIRS *French, XVIII Century*

Shaped back and seat covered in plum-colored velours; molded and gently voluted frame and supports carved with a scallop shell on the crest and skirt.

100

252. DECORATED COROMANDEL LACQUER FOUR-FOLD SCREEN

Incised and painted with figures of Immortals in the Shou Shan or Taoist paradise, in a black ground; red and gold frame.

Height, 55 inches; length, 5 feet 4 inches

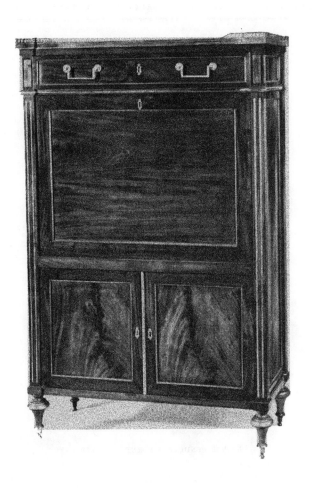

[NUMBER 248]

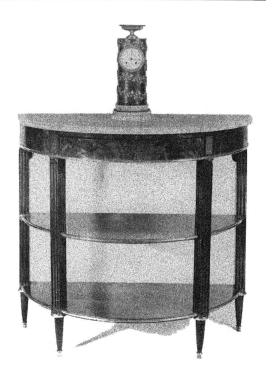

[NUMBER 253]

EMPIRE PENDULE À BORNE: NUMBER 193

253. PAIR LOUIS XVI ACAJOU DEMI-LUNE THREE-TIER BUFFETS

French, XVIII Century

660-

Composed of two shelves rimmed with *cuivre doré* moldings, a drawer in the upper part; on grooved square supports extended into round tapered short legs. Top covered with white marble slab.

Height, 38 inches; length, 42½ inches

[See illustration of one]

70

254. RÉGENCE CARVED, LAQUÉ, AND PARCEL-GILDED TRUMEAU
WITH OIL PAINTING French (?), Early XVIII Century

175

Laqué green, ornamented with Régence rococo carved and gilded frame enclosing an oblong mirror in two parts, surmounted by an oil painting of rustics and an equestrian figure in a landscape.

Height, 7 feet 10 inches; width, 51 inches

255. DECORATIVE PAINTING IN OILS French School, XVIII Century

50

A lakeside landscape, the shores with heavy verdure, with four figures of maidens bathing in the foreground.

Height, 43½ inches; width, 30 inches

256. DECORATIVE PAINTING IN OILS: DESSUS-DE-PORTE French School

50

Southern landscape with a lake and buildings, and figures of men and women in the foreground, fishing.

Height, 12 inches; length, 41½ inches

257. DECORATIVE PAINTING IN OILS: DESSUS-DE-PORTE
Southern French School, Late XVIII Century

2/0

Depicting two ladies and two gentlemen in Directoire costumes, engaged in a game of battledore and shuttlecock; in the background, the buildings of a *caserne*. *Height, 16½ inches; length, 51 inches*

258. PAIR DESSUS-DE-PORTES PAINTINGS EN CAMAÏEU
French School, circa 1800

50

One depicting a Roman warrior feasting; the other, classical figures watching a cock fight and listening to a prophet, and the dancing Pan surrounded by a nymph and *putti*. Slate blue background.

Height, 20 inches; length of one, 103 inches; of the other, 48 inches

Note: These panels were in the collection of the Prince d'Essling, Palais Masséna, Nice, now the Museum.

259. GILDED THREE-FOLD SCREEN, INSET WITH OIL PAINTINGS
French, circa 1700

180

View of a wooded landscape with figures of nobles and ladies in the foreground, preparing for a hawking expedition; at the left, a man with a hawk and an attendant holding a gray horse. Reeded and gilded frame of later date.

Height, 6 feet 3 inches; total length, 8 feet 4 inches

71

260. LOUIS XVI CARVED AND LAQUÉ BEDSTEAD *French, XVIII Century*
60

With rectangular end-panels and fluted side-rails carved with fluting and guilloche ornament and embellished with formalized leaf finials. Lacquered soft white and pale green.

Length, 6 feet 6 inches; width, 42 inches

261. DIRECTOIRE CARVED AND LAQUÉ BEDSTEAD *French, XVIII Century*
150-

Rectangular head-panel upholstered and covered in contemporary crimson and white silk lampas. Frame lacquered white and pale green.

Length, 6 feet 6 inches; width, 50 inches

262. PAIR RÉGENCE SCULPTURED OAK DOORS

Normandy, Early XVIII Century
200- Slightly convex and richly carved in relief with urns of foliage, acanthus volutes, shells, and martial trophies; framed in molded panels.

Height, 7 feet 1 inch; width, 32 inches

263. PAIR RÉGENCE SCULPTURED OAK DOORS

Normandy, Early XVIII Century
160 - Matching the preceding doors. *Height, 7 feet 1 inch; width, 23 inches*

264. LOUIS XV CARVED MARBLE MANTEL *French, XVIII Century*

Gracefully curved and molded frieze carved with a scallop shell at the centre, the stiles molded; repaired.
170-

Outside Measurements: Height, 45 inches; length, 5 feet 5 inches
Inside Measurements: Height, 38 inches; length, 50 inches

FINE ORIENTAL RUGS
AND A MORTLAKE TAPESTRY

265. MORTLAKE TAPESTRY *XVII Century*

ANTONY AND CLEOPATRA. The queen is represented seated on a throne under a draped canopy and welcoming Antony, who kneels in obeisance and is accompanied by two warriors. At the queen's right are two attendant women with ewers of wine and flowers; to the right, a vista of formal gardens and fountains. Woven in ivory, yellow, blue, and green with touches of crimson and highlighted in silk.
920

Height, 6 feet 7 inches; length, 10 feet 9 inches

[See illustration]

72

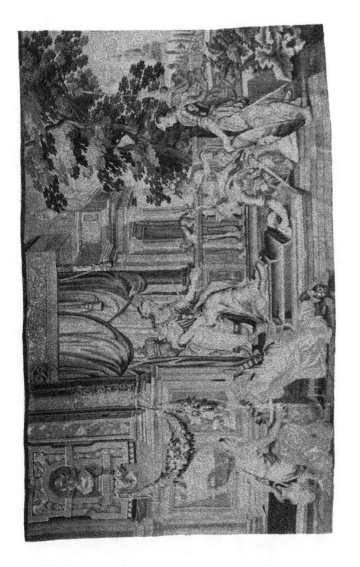

266. ANTIQUE FEREGHAN SEREBEND RUG

Closely knotted small rug, the crimson field occupied by rows of pear-shaped flower motives in soft blue and ivory; the border with flower vines on white. *Length, 5 feet 9 inches; width, 3 feet 10 inches*

2 6 o —

267. SEHNA BIRD RUG

Finely knotted rug, the ivory field occupied with a flower and trellis design enclosing Arabic characters in small pendant floral motives and also featuring a pair of juxtaposed peacocks; the two narrow borders filled with undulating vines. *Length, 6 feet 3 inches; width, 4 feet*

/ 8 o —

268. ANTIQUE FEREGHAN RUG

Closely knotted rug with Herati field in crimson, blue, and ivory white; the two borders of flowers on red and light green.
 Length, 6 feet; width, 4 feet 5 inches

2 6 o

269. ZILLI SULTAN RUG

Closely knotted rug with soft ivory field occupied by rows of small crimson flowers and leaves in green and indigo, the narrow border with checkered guard stripes; a few small repairs.
 Length, 6 feet 3 inches; width, 3 feet 10 inches

/ 9 o

74

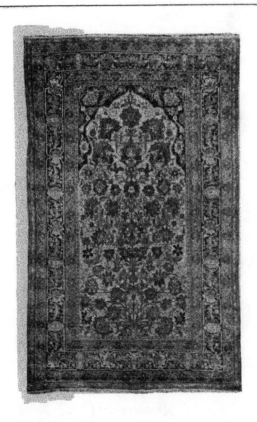

[NUMBER 270]

270. PERSIAN SILK PRAYER RUG

Ivory-white mihrab filled with formalized clusters of carnations, peo-
nies, and chrysanthemums and leaves in soft red, blue, and green. The
three borders with undulating vines and flowers in a red and deep blue
ground. *Length, 6 feet 11 inches; width, 4 feet 2 inches*

[See illustration]

75

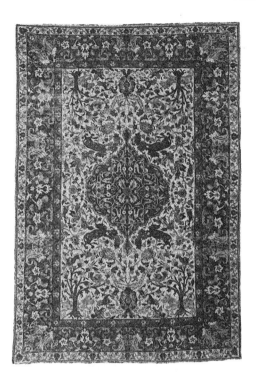

[NUMBER 271]

271. ROYAL PERSIAN ANIMAL RUG

Superbly knotted rug of sixteenth century design. The ivory white field sustains an intricate design of juxtaposed unicorns and birds and other animals, interspersed among a rich tracery of carnations, peonies, and magnolia blossoms and centred by a palmetted medallion of flowers and leaves in a dark blue ground. The main border is filled with a profusion of scrolled leaves and blossoms in a dark green ground matching that of the centre medallion. *Length, 7 feet 2 inches; width 5 feet*

[See illustration]

76

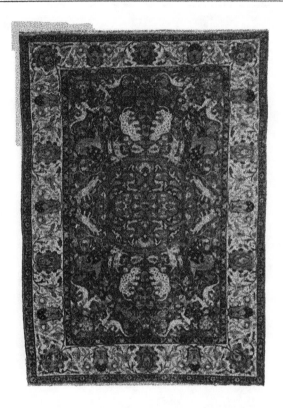

[NUMBER 272]

272. ROYAL PERSIAN ANIMAL RUG
 Superbly knotted rug somewhat similar to the preceding, with sixteenth
 century design. The crimson field is occupied by a rich design com-
 posed of juxtaposed animals and monsters and naturalistic flowering
 vines centered by a flower medallion. The main border with large
 pyramids and undulating vines on soft white.
 Length, 7 feet; width, 5 feet
 [See illustration]

77

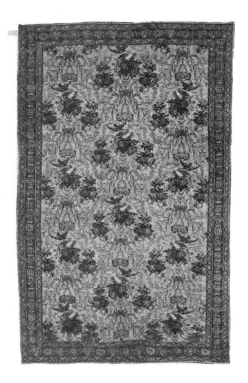

[NUMBER 273]

273. HAMADAN SEHNA RUG

Finely knotted rug of Karabagh design with old ivory field occupied by semi-naturalistic clusters of red and green and deep blue flowers and birds; the three narrow borders with angular flowers and vines in deeper colors. *Length, 6 feet 8 inches; width, 4 feet 5 inches*

[See illustration]

78

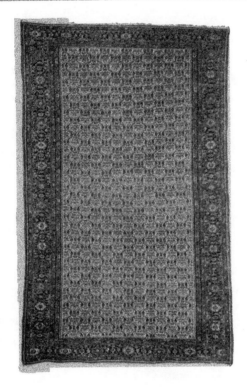

[NUMBER 274]

274. ANTIQUE ROYAL FEREGHAN RUG

Splendidly knotted small rug with trellised and flowered ivory white field; the border occupied by angular vines and flowered medallions in a dark ground. *Length, 6 feet 6 inches; width, 4 feet*

[See illustration]

79

275. CHINESE RUG *Ch'ien lung*
Yellow field stippled with brown and occupied by five circular medallions of flowers and leaves in rose pink, light and dark blue, and white, the border with similar floral motive on rose, flanked with blue guard stripes. *Length, 8 feet 2 inches; width, 5 feet 2 inches*

2 5 0

276. ANTIQUE KULAH 'TREE OF LIFE' RUG
Odjaklik with narrow centre field of old rose sustaining a formalized 'Tree of Life' motive in soft colors, the four borders filled with angularized flowers and vines on bright blue, soft white and dark brown; lined. *Length, 12 feet 3 inches; width, 5 feet 4 inches*

[See illustration]

300—

277. LOUIS PHILIPPE AUBUSSON RUG *French, XIX Century*
Designed with four large bouquets of white and pink roses and green leaves framed in scroll motives and surrounding a central lozenge-shaped medallion of white carnations, in a pale turquoise ground, bordered in terra cotta brown.
Length, 8 feet 7 inches; width, 6 feet 6 inches

190

278. ANTIQUE SAMARKAND RUG
Characteristic design of large circular medallions of Mongoloid symbols in soft yellow and pale blue in a soft rose ground; four borders of key-fret and zigzag ornament.
Length, 11 feet 4 inches; width, 6 feet 1 inch

110—

279. PERSIAN RUG
Featuring animals, human figures, and flowers in rich profusion in an ivory ground. *Length, 5 feet 6 inches; width, 4 feet*

90

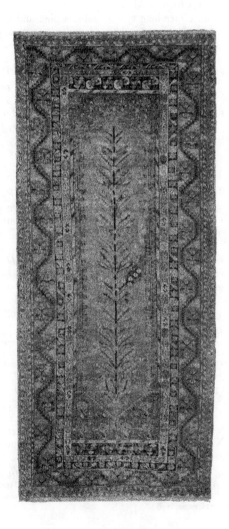

[NUMBER 276]

280. TWO ANTIQUE CHINESE MATS

5̸5̸ - Square mat of Ch'ien-lung type in salmon pink and blue. Saddle mat
with two floral medallions in blue ground with yellow border.
Lengths, 2 feet 4 inches and 4 feet 4 inches

281. FIVE PAIRS OF LOUIS XIV BLUE SILK BROCATELLE DAMASK
WINDOW HANGINGS *French, circa* 1700

4̸00̸— Patterned with a bold baroque floral motive and of a beautiful shade
of Nattier blue; lined with white sateen and trimmed with gimp.
Length, 9 feet 6 inches; width, 27 inches

DECORATIVE OLD BINDINGS

282. ELEVEN BINDINGS *XVII-XIX Century*

Comprising eleven volumes in full crimson or brown calf, small 8vo
and 12mo in size, variously gilt tooled, including four armorial bind-
30— ings; by French, Italian, and English binders.

283. FOUR BINDINGS *XVII-XVIII Century*

Comprising four folio volumes: two in full crimson morocco, gilt
tooled, one with the Richelieu arms and the other with the arms of
Louis Alexandre de Bourbon, son of Louis XIV; one in full mottled
30— calf, with gilt tooled back (worn); and another in full limp vellum.

> *Note:* The vellum binding is on a copy of Jacobus Philippus Bergomensis'
> *Supplementum Supplementi Chronicarum* (Venice, 1508), illustrated with wood-
> cuts, with chronologically arranged text in Italian containing an account of the
> discovery of America under the date 1492 (lacks four leaves earlier in the text).

284. FOUR GILT TOOLED BINDINGS *French, XVIII Century*

30— Comprising three volumes in full crimson morocco, 8vo and small 8vo
in size, of which one is elaborately tooled with the arms of Marie
Josèphe de Saxe, mother of Louis XVI, and another bears the arms
of Louis XV; and one volume, small 4to, in full mottled calf (worn,
front hinge cracked).

> *Note:* The calf binding is on a copy of Bernard's *L'Art d'Aimer* (Paris,
> *circa* 1777), with an engraved title-page and seven plates by Martini and Eisen;
> the armorial bindings are on copies of the *Office de la Semaine Sainte* (Paris,
> 1746 and 1726 respectively).

Session # 15 435
1C

[END OF SALE]

APPRAISALS

For United States and State Tax
Insurance and Other Purposes

The American Art Association-Anderson Galleries, Inc., will furnish appraisals, made by experts under its direct supervision, of art and literary property, jewelry, and all personal effects, in the settlement of estates or for inheritance tax, insurance, or other purposes.

Upon request the Company will furnish the names of many trust and insurance companies, executors, administrators, trustees, attorneys and private individuals for whom the Company has made appraisals which not only have been entirely satisfactory to them, but which have been accepted by the United States Estate Tax Bureau, the State Tax Commission, and others in interest.

The Company is prepared to supplement its appraisal work by making catalogues of private libraries, of the contents of homes, or of entire estates, such catalogues to be modeled after the carefully-produced sales catalogues of the Company.

AMERICAN ART ASSOCIATION
ANDERSON GALLERIES · INC
30 EAST 57TH STREET · NEW YORK

Composition and Presswork
by

𝓣𝓑

PUBLISHERS PRINTING COMPANY
William Bradford Press
NEW YORK

CPSIA information can be obtained
at www.ICGtesting.com
Printed in the USA
BVHW040903160119
537965BV00009B/204/P